WOMEN IN THE DARK

FEMALE PHOTOGRAPHERS IN THE US, 1850-1900

KATHERINE MANTHORNE

SCHIFFER
PUBLISHING

4880 Lower Valley Road • Atglen, PA 19310

Cover and Interior Designed by Ashley Millhouse

Cover image: Unknown maker, American. *Woman Daguerreotypist with Camera and Sitter*, ca. 1855. Ambrotype, 3 ¼ x 2 ¾ inches (8.3 x 7 cm). The Nelson-Atkins Museum of Art, Kansas City, Missouri. Gift of Hallmark Cards, Inc., 2005.27.5
© Nelson Gallery Foundation.
Image Credit: Thomas Palmer

Back cover image: *"Yes or No" Series: Letter C*, postcard, ca. 1900, private collection.

Type set in Neutra Text/Baskerville

ISBN: 978-0-7643-6016-9
Printed in China

Published by Schiffer Publishing, Ltd.
880 Lower Valley Road
Atglen, PA 19310
Phone: (610) 593-1777; Fax: (610) 593-2002
E-mail: Info@schifferbooks.com
Web: www.schifferbooks.com

For our complete selection of fine books on this and related subjects, please visit our website at www.schifferbooks.com. You may also write for a free catalog.

Schiffer Publishing's titles are available at special discounts for bulk purchases for sales promotions or premiums. Special editions, including personalized covers, corporate imprints, and excerpts, can be created in large quantities for special needs. For more information, contact the publisher.

We are always looking for people to write books on new and related subjects. If you have an idea for a book, please contact us at proposals@schifferbooks.com.

DEDICATION

To my father, Joseph Parker Manthorne,

the family photographer who inspired me

&

To my husband, James Lancel McElhinney,

who helped me shed light on the Women in the Dark

CONTENTS

ACKNOWLEDGMENTS

From the moment that I began pursuing these American women photographers over a decade ago, I have benefited from the help of many colleagues and friends. Anyone who works on this material owes a debt of gratitude to the late Peter Palmquist for his many insightful publications (many of which are cited in these pages) and his photographic collection that he bequeathed to Yale University's Beinecke Library. In the same repository is the Julia Driver Collection of Women in Photography, whose online database is also indispensable to all of us in the field. I availed myself of many other libraries and museums that are making their collections increasingly accessible, but here I want to mention two in particular: the Metropolitan Museum of Art, whose open-access policy has been a boon to researchers, and the New York Public Library's Photographers' Identities Catalog (PIC), where David Lowe generously shared his knowledge. Shauna Howe, William Simmons, and María Beatriz H. Carrión, an art history doctoral student at the Graduate Center, City University of New York, were a great help in compiling materials. But my greatest appreciation goes to the hundreds of people I never met who collected and preserved photographs of these faces from the past so that future generations could enjoy and study them.

INTRODUCTION

Absence

About the time that New York's National Academy of Design held its annual fine art exhibition in the spring of 1869, its former president Asher B. Durand visited the studio of leading photographer Abraham Bogardus on Broadway and 27th Street to have his portrait taken. The resulting *carte de visite* was typical of the work that established the Bogardus name as synonymous with quality, showing the wizened landscapist—often called the dean of the Hudson River school—seated in half length with his head and torso rendered in high detail against a plain background (1869, Archives of American Art). This was at the height of the American craze for the *carte de visite*, an inexpensive photographic print produced from a negative in multiple copies and affixed to a card measuring 2 1/2 by 4 inches. Incredibly prolific, Bogardus opened a studio and gallery in the early days of photography in 1846 and became highly successful portraying prominent American men: "During the first popularity of the Carte-de-Visite Mr. Bogardus kept three skylights busy," we learn, "and delivered from 68 to 100 dozens of Cartes per day."[1] With the photographic boom continuing in the aftermath of the Civil War, he saw the need for an organization to promote the field's professional standards and artistic aspirations, and in 1868 helped found the National Photographic Association (and served as its president for the first five years).

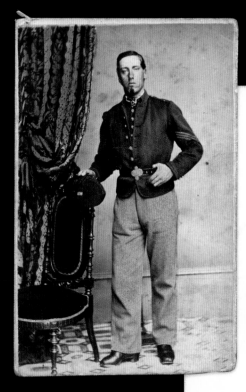
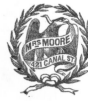

A group portrait taken of the members at their first conference in 1869 in Philadelphia shows an august body composed of many of its well-known practitioners. No women were present. They were barred from joining this or any other photographic organization at the time. In truth, however, the portrait was far from representative of the profession, which by that date included legions of women working in every phase of production—not only in New York, but also across the entire country. They were an integral part of the field, working not only as photographers, but also as studio managers, gallery owners, retouchers, colorists, mounters, and authors of how-to manuals. The accounts of the female photographers in this book demonstrate the role they played in advancing their profession and visual culture more broadly during the second half of the nineteenth century in the United States.

Take the example of Matilda Moore (b. ca. 1832, active ca. 1860–1883), who ran a successful studio in New York City for over two decades on Canal Street, between Varick and Sullivan Streets (fig. IN-1). "Mrs. Moore," as she signed her work, was an active member of New York's photographic community in the 1860s and 1870s, yet her name rarely appears in the literature. Attempting to reinsert women such as Moore and her sisterhood into the historical record presents the opposite challenge to the majority of women in the visual arts. With painters, some references remain of their long-forgotten artistic reputations, but the body of work they produced is often scattered or lost. Moore, by contrast, is known primarily through a few hundred surviving photographs (compared to 200,000 by her leading male contemporary, Bogardus) only by the fact that she stamped her logo on their versos. Every portrait she made, every photographic she sold, was identified on the reverse side with her logo, "Mrs. Moore, 421 Canal Street, New York" (fig. IN-2). Her personal back mark, printed on these small cards, is the equivalent of the crumbs dropped by Hansel and Gretel in the forest, and leads us back to her. This commercial branding of female identity forces us to abandon the stereotype of the middle-class white women sheltered from the world of commerce. These enterprising women set up their establishments side by side with men, whether it was in a nascent western town or—as in Moore's case—on one of the most heavily trafficked streets of one of the busiest cities in the world, and made their livings as photographers.

Carving Out a Place in History

Once photography was "born" in 1839, it quickly evolved into one of the century's most popular formats for recording faces and places. By the 1850s, hundreds of women operated cameras and created images that contributed to the history of the medium. Every city and town in America had a photographic district, and often that district was home to at least one female photographer. They brought photography to embryonic towns or city neighborhoods, hoping they could contribute to the growth of the community, and gambling in turn that its development would nurture their struggling businesses. They were enterprising, talented, and resourceful. By the century's end the number of female photographers was estimated to be in the thousands. Yet, with a few exceptions, the history of nineteenth-century photography is told largely as a story of male achievements. Who are these women, what can we recover of their stories, and how distinctive are the images they shot? And what was their role in the forging of the nation and of its visual culture in these seminal

decades? This book seeks to start answering these and related questions. The title *Women in the Dark* refers both to the conditions of the darkroom in which these women performed their magic and to the fact that they have remained largely forgotten.

By 1839, Louis-Jacques-Mandé Daguerre in France and William Henry Fox Talbot in England had created competing, pioneering formats: the daguerreotype consisted of a unique image on a mirror surface with stunning detail, while Talbot's calotype produced a paper negative from which multiples could be made, albeit far less distinct. In 1851, Frederick Archer invented the collodion process, which combined the best aspects of its predecessors: a negative image on a transparent support that could be printed over and over on albumen paper with sharp resolution. Albumen print portraiture became a mainstay of photographic studios, especially compact card portraits: the *carte de visite* had its heyday in America during the 1860s and 1870s, after which the larger cabinet card replaced it. Women were prolific in both these formats.

Cartes de visite (abbreviated cdv) are fascinating documents: small photographic portraits printed on paper and mounted on 2½-by-4-inch cards. There was a robust market for such images of celebrities and leaders: President Abraham Lincoln, African American leader Frederick Douglass, and actor Edwin Booth were all huge sellers. But the majority represented everyday folk who posed nervously in the photographic studio, eager for an inexpensive portrait to share with loved ones and record them for posterity. We seldom know the identities of these sitters who stare out at us through a sepia haze, and rarely do we think about the photographers who took them. Yet, turning the card over often reveals a maker's mark and precious historical information. Such research collectively provides a roster of female photographers. *Women in the Dark* focuses on American women who made *cartes de visite*, tintypes, and related photographs from the 1850s through the 1870s. By 1880, dry-plate photography came into widespread use, which greatly streamlined the treatment of the plate. Simultaneously, the larger cabinet cards replaced the cdvs, which allowed for a bigger image and greater technical consistency. We examine the cdvs and cabinet cards successively against the concurrent settling of the western frontier, the rise of eastern urban centers, and the first women's movement in America.

This narrative crosses the boundaries between high and low art. It opens up new avenues of research and new approaches to narrating history. The women who are the subject of this book are largely under the radar. Groups of photographs tell the stories of Mary Ann Jube of New York City, Illinois's Candace Reed, and Emily Stokes in Boston: stories of immigration, migration, changing technologies, and female survivors. Some women colored or retouched photographs and then moved up to camera operator, while others were in business with husbands and, when they lost the men to war or disease, carried on alone. Mostly they worked indoors in the studio, but a few—such as Eliza Withington of Ione, California—devised a portable camera outfit and went out into the landscape. This book also includes the material culture of photography, from the chair in which a sitter posed to the album in which the photograph was displayed.

This subject is grossly unrecognized. Naomi Rosenblum's *A History of Women Photographers* (2000) mentions a few nineteenth-century American women. State and regional directories have been compiled, mainly by

collectors, to provide basic data: dates of operation, studio addresses, and sometimes sample images. Photographic collections amassed by Peter E. Palmquist and Julia Draper—both at Yale University's Beinecke Library—provide researchers the opportunity to see these images firsthand. Palmquist's pioneering publications with a special focus on women in the West provide inspiration and a solid foundation to subsequent work.[2] Building on these efforts, I aim to animate this history by telling the stories of select women who epitomize significant themes and trends in the field, rather than providing a broad survey. Matilda Moore's cdvs of Civil War soldiers illuminate the efforts of photographers all over the country to capture the likenesses of men heading off to war, for example, while Eliza Withington's pioneering efforts to record the Northern California scenery help contextualize the female impulse to document landscape. Equal parts photo history, social history, material culture, and historical biography, my study retrieves the careers of representative women and reinserts them into American visual culture.

We follow two generations of these women: the pioneers of the 1850s–1870s who forged a new path, and those of the 1880s and 1890s who took advantage of new technology to refine the medium. The earlier generation could rely on attracting customers via the sheer novelty of being photographed by a woman, but also hedged their bets by offering multiple services, such as sewing, hair jewelry, or—occasionally—midwifery. The later generation, by contrast, worked in an increasingly professionalized environment. They improved their craft, modified optics, and learned the latest chemistry. Some women conformed to social expectation and specialized in babies or children, but many strained against convention. They demonstrated remarkable business acumen, including Mrs. James O'Donoghue of Frankfort, Kentucky, who strategically set up shop near the state capitol and lured representatives and senators into her chair. Others such as Candace Reed opened franchises in several locations. Their work demonstrates a level of quality equal to their male counterparts, while their personal stories reveal their desire to reach beyond the choices usually offered them: wife, mother, teacher, seamstress, or prostitute. These innovative women demonstrated their need for freedom, independence, and the right to earn an honest and rewarding living. I excavate their careers not for mere biographical value, but rather to highlight the intersection between photography and society. The goal is to bring women still in the dark out into the light, and to utilize their histories to elucidate diverse dimensions of photographic practice and of American life.

Format of the Book

This book is divided into six chapters that cover major themes that highlight the achievements of these women. Chapters are further divided into a series of mini-chapters that feature the profile of a single photographer. Combining whatever biographical detail is available with close readings of photographs, these mini-chapters identify the particular contribution each woman made to nineteenth-century photographic practice. Arranged in a loose chronology, these chapters integrate personal stories with historical developments in the medium and the nation, as follows.

I. The Pioneers & Evolving Photographic Techniques uncovers the female forerunners who mastered the early technical processes to create portraits in ambrotypes, tintypes, and *cartes de visite* and reveals the distinctions among these mediums.

II. The Civil War Era witnessed a photographic boom, with female photographers playing a dual role. First, they shot the military men departing for the battlefields or taking a leave from their duties to have a portrait to send back home. Just as importantly, they made portraits of wives, mothers, and sweethearts as mementos for soldiers. Scratched tintypes and dog-eared cdvs from this period testify to the fact that people treasured these keepsakes and kept them close.

III. Family Matters demonstrates that, from the outset, photography was central to family life. Even though wedding portraits were originally taken in the studio and not on-site, they quickly became integral to the event. Baby pictures were another important category of image, ranging from bouncing young infants and toddlers to the sad renderings of recently deceased children that were treasured by parents in an era of high infant mortality. A large number of sister duos constitute another popular category of photography, providing a springboard for contemplating the significance of that relationship for nineteenth-century women. A discussion of the albums that women assembled and made the centerpiece of parlor gatherings provides another perspective on the ways in which photographs helped cement a family together. Chapter III ends with a discussion of photographer Lucretia A. Gillett, for whom relations with her mother and father were so important that she rejected the option of seeking her fortune in larger communities with more opportunities and remained with them, working in her hometown of Saline, Michigan.

IV. A Visit to a Woman's Portrait Studio traces the experience of the client/sitter, from the time she or he decides to have a portrait taken to picking up the finished product. It reconstructs the physical environment of the average photographic gallery, paying particular attention to subtle nuances that occur when the owner of the establishment or camera operator is female. It also teases out the anxieties that accompanied sitting for a portrait: what to wear, how to style hair, and the times of day and weather conditions best suited for the rare occasion.

V. Outdoors: Landscape & Architecture follows the small number of women who exited the portrait studio to make photographs out of doors. In California, Eliza Withington wrote of her efforts to capture the scenery in the northern mining areas, while Sarah Short Addis straddled the border with Mexico. In Texas, Mary Jacobsen produced an extended series on the architecture of San Antonio's Spanish colonial missions. Marion "Clover" Hooper Adams roamed the shoreline of Massachusetts close to the family home, while Mary Jane Wyatt decked out a railroad car as a portable studio and found subjects along the line.

VI. The New Woman & Women's Rights draws parallels between the development of photography and the rise of the women's movement. Beginning with cdvs of Amelia Bloomer wearing her reform dress and concluding with self-portraits by Frances Benjamin Johnston demonstrating the use of the camera to young

novices, chapter VI establishes the ways in which women deployed photography to advance their case for suffrage and equal rights.

We conclude with the dawn of a new photographic era and the birth of "the Kodak Girl."

Legacy of the "Women in the Dark"

By the 1850s, the term "self-support" came into use to earmark a stratum of respectable women who—whether they were widows, orphans, spinsters, unwed mothers, divorced women, or those who had suffered reversals in family economics—were forced to support themselves. In the early 1800s, urban women had few options for reputable paid work, and as the century progressed, their options narrowed even further as immigrants usurped jobs in domestic service and the clothing trade. In 1869, *Harper's Bazaar*—edited by Mary Louise Booth—ran a double-spread illustration "Women and Their Work in the Metropolis" that presented a panorama of female employment in New York City. Front and center is the proverbial seamstress—overworked and underpaid—surrounded by vignettes of her colleagues setting type, binding books, making corsets and umbrellas, and mounting photographs.[3] This last-mentioned activity acknowledges women's entrance into the field that had been expanding rapidly since the "invention" of photography in 1839. The timing was significant, offering fresh opportunities just as the old ones were being taken away by Irish, German, and other transatlantics seeking refuge in American cities.

Little wonder, then, that women opted for this new, burgeoning technology where they could get in on the ground floor. There was no a priori hierarchy or division of labor, no hallowed guilds or schools that excluded them. They were as free as men to order how-to manuals, study the work of Mathew Brady or other leading figures, and experiment on their own. Like their male counterparts, they had to learn by trial and error how to operate cameras, develop and print the pictures, and market their trade. Some were technically minded, others were more steeped in the artistry of it, and many had a practical knack for business. Mrs. Moore seemed to have been blessed with all three. We may never know precisely why all these women took up photography, but the stories of this representative handful of practitioners provide some insight into their motivations through the pictures they produced.

This book is not intended to be polemical—it does not argue that women equaled men technically or artistically. Instead it tries to demonstrate that female photographers deserve our attention because they pushed boundaries, socially as well as formally. It is meant to challenge our expectations, to force us to rethink who could be a photographer in the nineteenth century and how women were able make images of interest and power. Examining worn *cartes de visite* and cabinet cards and finding the names of their female creators, of whom I had been entirely unaware, inspired me to search for the legions of women who worked for decades producing technically skilled and historically important photographs, and ultimately to write this book. So the legacy of Mary Ann Jube, Matilda Moore, Candace Reed, and the other "Women in the Dark" lives on.

CHAPTER I
THE PIONEERS & EVOLVING PHOTOGRAPHIC TECHNIQUES
Introduction

Nobody, regardless of gender, had access to photographic schools or classes in the early days of the medium. Women as well as men learned how to mix chemicals, prepare the plates for exposure, and operate the camera by apprenticing with a more experienced photographer—often a family member—and studying how-to manuals, supplemented with trial and error. Famous photographers such as Mathew Brady attracted neophytes who visited him to observe his operations, but few could afford such elaborate establishments as his fourth and last New York studio, which he opened in 1860, called Brady's National Portrait Gallery, at the corner of Broadway and Tenth Street.[4] These circumstances leveled the playing field, since no one had the advantage in terms of training.

The pioneering women made photographs in a series of processes and formats as they became available, initially daguerreotypes, ambrotypes, and tintypes. Each one had a characteristic physical presence that invited touch and engaged the person who possessed it in a highly intimate manner. Daguerreotypes and ambrotypes were prepared on a delicate mirror or glass surface that had to be

I-A-1 May Ann Jube, New York, *Young Man*, ambrotype (sixth plate), ca. 1855, private collection

protected by inserting them into a hinged case. Depending on the size, they could be held in the palm of the hand and viewed close-up. Smaller-sized versions might be placed into a locket and worn on the body, like a miniature. With tintypes, the image was imprinted onto a thin metal sheet that might be inserted into a paper card but was quite durable, without need of further protective covering, before being slipped into a pocket or a purse for easy portability. On the Bowery in New York, Mary Ann Jube made ambrotypes, while Mrs. Fletcher in Ohio was one of the many who made tintypes.

After 1855, paper photography emerged, and with it, standardization of formats such as the *carte de visite*, small photographic prints mounted on cards measuring approximately 2½ by 4 inches. They were the equivalent of visiting or business cards, with a portrait affixed to a cardboard mount. Photographic portraiture underwent something of a revolution with the advent of the cdv (as they were called), which enabled photographers to produce likenesses rapidly and relatively inexpensively. They became so popular that the press dubbed the craze "cartomania." Studios attempted to mimic the tropes of fine art painted portraits, using pillars, a few pieces of furniture, and painted backdrops to set the scene, while parasols, books, and fans were placed in the hands of sitters for added refinement. Some cdvs were placed in albums, but many circulated among friends and family—nineteenth-century survivors display dog-eared corners, worn edges, and general wear and tear. People did not just look at these early photographs but engaged with them via multiple senses in private and personal ways. Recognizing the role they played in sealing social relations, Oliver Wendell Holmes called them the "sentimental greenbacks of civilization."

Location, location, location: it was just as critical to businesses in the nineteenth century as it is today. Since women attempted to situate their studios strategically, it is important to consider their whereabouts in the towns, cities, and even specific neighborhoods where they worked. Attempting to reconstruct their settings—from Mary Ann Jube on the Bowery to Candace Reed in a midwestern river town—provides one means of understanding how they functioned within their social environments.

Making Ambrotypes on the Bowery in the 1850s: Mary Ann Jube

"The Bowery is one of the great highways of humanity, a highway of seething life, of varied interest, of fun, of work, of sordid and terrible tragedy," New York police commissioner Theodore Roosevelt observed upon his visit there in 1913, "and it is haunted by demons as evil as any that stalked through the pages of [Dante's] Inferno."[5] In the 1850s, however, it was a different scene when female photographers set up their studios: Mary Ann Jube at No. 83 Bowery, Mrs. Phillips' Gallery at No. 111 Bowery, Mrs. Balch at No. 123 Bowery, and by 1860, not far away, Mrs. Moore at 421 Canal Street.[6] The Bowery Theater, first built in 1826 between Canal and Hester Streets, set the tone for the area. While Broadway theaters attracted what might be called highbrow audiences—cultured and elegant—the working-class or lowbrow audiences thronged to the Bowery. So as photography became less expensive and more available in the form of ambrotypes and tintypes in the 1850s, it was

natural that practitioners would find a home in this section of the city. This neighborhood was the domain of working-class youth culture, where Bowery Boys (or B'hoys, the slang term) walked with a swagger and kept company with their "girls"—young working women, likely shopkeepers or seamstresses. They strolled up and down the busy thoroughfare, and, if they had a little money left from their wages, they pursued additional amusement. They could attend a show—black-face minstrelsy was born here, drop into the dime museum and see the curiosities, or consume oysters and beer. And sometimes these young people noticed an advertisement at street level, sought out one of the galleries located on the upper floors, and had their pictures taken.

These studios depended on the working-class clientele, who often labored ten hours a day, six days a week, leaving only nights and Sundays free. New York law technically forbid businesses from operating on Sunday, but many small-time owners remained open on the sly to accommodate those with limited leisure time, and the police apparently turned a blind eye. A fascinating notice in the city press tells us that one Thomas S. Jube blew the whistle on his neighbors:

> Arrest of Daguerreotype Artists. The following named persons were yesterday arrested on complaint of Thos. S. Jube of No. 83 Bowery, who charges them with practicing their business on Sundays, contrary to law: Mr. Reeves, corner of Grand-st. and Bowery; Mrs. Baulch [*sic*], No. 113 Bowery; Mr. Weston, No. 132 Chatham-st. They were taken to the Second District Police Court and held for examination.[7]

Whether he was motivated by respect for the Sabbath or the fear of competition is uncertain, but this incident provides insight into the cutthroat environment of the Bowery.

The same Thomas S. Jube who made the police report operated, together with his wife, Mary Ann Sidell Jube (1820–1881), one of the many photographic establishments that enjoyed a healthy trade in the 1850s making portraits that conveyed a respectable demeanor of the working-class habitués of the Bowery.[8] Although little is known about the Jubes, they were apparently enterprising enough that they ran an advertisement in the *New York Herald* on at least one occasion in 1856. "What! Daguerreotypes Dead?" it read, referring to the early process employing an iodine-sensitized silvered plate developed by exposure to mercury vapor.[9] The ad continued:

> Large size ambrotypes for fifty cents, including a fine case. – What! daguerreotypes dead? Yes, and buried by this late and beautiful discovery. These pictures are far superior to the daguerreotype, and but half the price, at JUBE'S gallery, 83 Bowery.[10]

The Jubes had begun by producing daguerreotypes, as we know from another press review: "JUBE'S, Bowery: Fair daguerreotypist. Very well arranged gallery and I should say his process was good."[11] They were among the many photographers who increasingly set aside that process in the mid-1850s, when the ambrotype, the tintype, and paper photography became cheaper and easier alternatives.[12]

One day in the mid-1850s, a young man wearing an ill-fitting jacket, plaid vest, and cravat entered the Jube studio and positioned himself in the posing chair to have this unique camera-exposed image taken and then hand-colored to give his cheeks a bit of a tint (fig. I-A-1). We know that the Jubes made it because they always affixed a small printed label to the frame, just below the oval opening for the photograph, which identified them.[13] This is an ambrotype: essentially an underexposed glass negative placed against a dark background, which creates a positive image. Photographers often applied pigments to the image, tinting cheeks and lips red as the Jubes did here, and sometimes adding gold highlights to jewelry, buttons, and belt buckles. An ambrotype such as this one was typically housed in a miniature, hinged case that was made of wood and given a decorative leather cover with an embossed design and a felt or velvet pad in the door, facing the image, along with a small latch on the side. They came in standard sizes, the most common of which was called a sixth plate—as this one is—measuring 2¾ by 3¼ inches.[14] In the United States, one could pay anywhere from 25 cents to $2.50 for an ambrotype, but Jubes's ad tells us that this young man must have paid 50 cents. Since in the 1850s this sum was the equivalent of approximately $10 today, it's likely that he intended this as a gift for his sweetheart or mother. Patented by James Ambrose Cutting in 1854, the ambrotype remained popular for only about ten years, until the mid-1860s, around the termination of the Civil War. They were replaced by *cartes de visite* and other paper print photographs, which could be reproduced in multiples.

Photographer of Civil War–Era New Yorkers: Matilda Moore

"Mrs. Moore," as she signed her work, was a contributing member of New York's visual culture in the 1860s and 1870s and demonstrated women's distinctive contribution to the field of photography. She ran a successful studio in New York City for over two decades at the same location at 421 Canal Street, between Varick and Sullivan Streets. The logo of Matilda Moore (b. ca. 1832, active ca. 1860–1883) changed from a cartouche to an eagle surrounded by a garland, but the inscription remained constant: "Mrs. Moore, 421 Canal Street, New York."

We may never know the motivation behind Matilda Moore's career choice, but a common thread among women photographers was the loss of a husband. In Illinois, Mrs. Reed initially worked with her husband, and after his death she took over the business. In California, Mrs. Cardoza divorced her husband and turned to photography to support herself and her children. City directories typically listed women only if they were heads of households; otherwise only the husband's name appeared, with no mention of his spouse. In the New York directory for 1865 is recorded "Moore, Matilda, wid[ow] Michael," but that is the sole reference to a husband uncovered so far. The US census for 1860 contains a few more tantalizing bits of information about Moore. She identified herself as a twenty-eight-year-old female and the proprietor of an ambrotype gallery, whose birthplace was Prussia. She possessed no real estate but indicated a personal estate of $1,000. More revealing still, she identified as a member of her household Joanna Gulliver, a black seventeen-year-old female born in New York. There was no occupation listed for Gulliver, but she must have combined the duties of a live-in domestic servant with those of Moore's photographic assistant in exchange for room and board.[15]

In 1861, *Frank Leslie's Illustrated Newspaper* showcased the new studio of famed photographer Mathew Brady with its elegant gallery hung with his most eye-catching and expensive "Imperial" portraits.[16] Moore likely visited it and studied his style of portraiture, the bread and butter of the urban studio photographer. It was around this time that she set up her studio, although it would hardly have approached the impressiveness of Brady's. But timing is everything, and soon Brady, like many photographers, would turn their lens on the Civil War, which erupted in April 1861. War is good for photography, since families who procrastinated having photos taken suddenly needed them for keepsakes to present to the son or brother or husband going off to war. And once those men acquired their uniforms, they stood proudly before someone's camera to have war-time separation pictures taken for wives, mothers, and sweethearts. Sometimes men from New York regiments, or those stationed nearby, found their way to Canal Street and paid Moore to photograph them. In 1861 and 1862 the city directory called her work "ambrotypes," but by 1865 it references "photographs."[17]

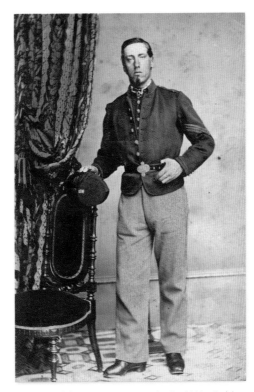

I-B-1 Matilda Moore, New York, *Civil War Soldier*, *carte de visite*, ca. 1861–65, private collection

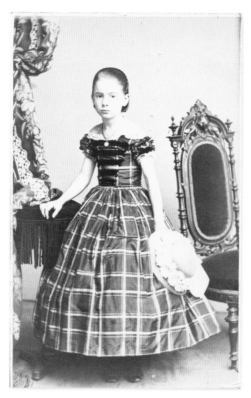

I-B-2 Matilda Moore, New York, *Young Girl with a Plaid Dress Holding a Hat, carte de visite,* ca. 1868, private collection

This military sitter (fig. I-B-1) must have been looking directly at her as she pulled the lens cap off the camera, counted the seconds, and replaced it. In that interval was she thinking of a son or a husband gone off to war? With her cdv camera she created eight shots, in four different poses; they all show him in full uniform, consisting of light pants, belt with metal buckle, and dark-toned New York jacket. Standing and in full length, he holds his hat in his right hand, which rests on an upholstered, armless chair. The identical chair, patterned floor covering, and drape appear in others of her cdvs, including a young girl in a plaid dress holding her hat (fig. I-B-2). Her youthful figure stands out against the background and appears more natural among the studio props than do the sitters in most run-of-the-mill cdvs. Moore effectively posed her clients to present the image of respectability. Sometimes sitters wanted a touch of color, as in the case of the soldier, likely done by a young woman she employed as a retoucher/colorist or perhaps by her own hand.

In 1883 the following notices appeared in the *Photographic Times* and *American Photographer:*

> For Sale. A good payable photograph gallery; situated on one of the best localities in New York. Will sell cheap. For particulars, address Mrs. Moore, 413 Canal Street, New York.

> For Sale. One 4 x 4 camera fitted with Morrison's copying lens; also, two backgrounds, and other accessories. Apply to Mrs. Moore, 413 Canal Street, New York.[18]

The following year, leading male photographer Abraham Bogardus ran a similar advertisement.[19] The photographic business was changing rapidly, as the Eastman Dry Plate Co. made prepared plates readily available commercially. As the new era dawned, the older photographic pioneers stepped aside. Sadly, that's the last we hear of Matilda Moore. But it was the discovery of her cdvs in antique malls and online marketplaces that sparked my search for her and the other women that make up this book.

Photographing the Faces of a Mississippi River Town:
Candace Reed

About 1842, at age twenty-four, Candace McCormick (1818–1900) married Warren A. Reed in St. Louis and moved with him to Quincy, Illinois. By 1848 they established a daguerreotype gallery on the southeast corner of the city square, where foot traffic would ensure a steady stream of customers.[20] Ten years later, she found herself a widow with a household that consisted of her mother-in-law, Phoebe (age sixty-eight), her two surviving children—Ferdinand and Warren—and her sister Celina (age thirty). In need of a means of supporting them, she sold her husband's daguerreotype stand and learned the new wet-plate collodion technique. By October, local newspapers announced the opening of her own photographic studio, the Excelsior Picture Gallery: "Mrs. Reed, assisted by Miss McCormack [*sic*], the most experienced operator in this city, has removed to No. 81 Hampshire Street, north side of the Public Square," she advertised, "where, with the BEST LIGHT IN TOWN, New Stock and perfect Cameras, she is prepared to surpass everything in the line of her art." Knowing that she faced increasingly stiff competition, and needing the work to feed her children, she tried to lure customers to her establishment by combining this technical bravado with a reliance on gender identity: "Patronize the widow, and thus give bread and education to orphans."[21]

Candace Reed's story echoes the experiences of many women of her generation whose success in the field of photography depended in part on two factors: family members who worked collectively in her studio, and her location in a thriving town, often in the Midwest or the West. Reed initially took up photography to help in her husband's business, working alongside him. After his death, Reed operated with her extended family, including her brother Wales R. McCormick—another local photographer—as well as her sister Celina. The women had to combine their professional responsibilities with domestic duties.

In the Midwest, opportunities sometimes opened up for women that would have been seized in cities by the male workforce. A county seat, Quincy boasted 6,000 residents at midcentury. In 1858—the year she announced her independent business—her town hosted the sixth of seven debates between Abraham Lincoln, the Republican candidate for the US Senate seat from Illinois, and incumbent Stephen Douglas, the Democratic candidate. The town's prominence ensured a healthy clientele that allowed her to develop a thriving commercial business. But other towns along the Mississippi were also growing and needed a photographer. With the help of her siblings, she was able to maintain operations in Quincy and open branches in Canton, Illinois, and LaGrange and Palmyra, Missouri. "Mrs. W. A. Reed, of Quincy, Illinois, respectfully informs the citizens of Palmyra and

Vicinity, that she has opened a Daguerrean room in Palmyra, over the Livery Stable of Mr. Thos. Hart, where she is prepared to execute orders for pictures, in the highest style of art, at prices ranging from 30 cents to 10 dollars," we read in the press in 1862. "Persons wishing pictures should remember to wear dark clothes, as much better pictures can thus be taken than in light clothing. AMBROTYPES, MELANOTYPES, AND FERROTYPES are taken in the most superior style, – Ladies and Gentlemen are solicited to call and examine her specimen pictures on exhibition."[22]

But with the Civil War raging, Reed soon left her home and studio to assume the role of nurse helping in the field hospitals in Tennessee, her home state. In her duties as nurse she wrote letters home for soldiers and helped in a hundred myriad ways. During her absence, her sister Celina likely operated the studio, perhaps with assistance from their brother. Upon her return, Candace continued to operate her flourishing commercial photography business, sometimes in multiple locations. By 1880 her daughter-in-law Mary J. Reed (age twenty-seven), who by then had lost her husband (Warren Jr.), and their child Alice C. Reed lived with her, repeating her own experiences as a widow. But the difference was that the elder woman continued to be the main provider.

Candace Reed photographed local citizens along the stretch of the Mississippi River that divided southern Illinois from Missouri, in the vicinity of Hannibal, Missouri, the boyhood home of Samuel Clemens (a.k.a. Mark Twain). Shot in her studio, they utilize well-posed figures and strategically placed props—plants, columns, and swag curtains—to create a comfortable domestic setting. Although most of her sitters go unidentified, we can glean certain facts from their appearance. The figure of a middle-aged man seated beside a fabric-covered table upon which he has placed his hat speaks to middle-class respectability (fig. I-C-1). In another picture, a toddler with blond hair perched on a fabric-covered seat gazes out of the picture with light-colored eyes, a testament to Reed's ability to cajole even this young sitter into cooperation (fig. I-C-2). Trafficking primarily in portraits, she introduced some diversity in her work by including infants, street scenes, postmortem images, wedding photographs, Civil War soldiers, and a likeness of Illinois governor and founder Quincy John Wood. Only a small portion of her highly extensive output can be traced today, partly because a fire in her studio in 1878 destroyed some of her work.[23] When she died in 1900, her obituary emphasized her charitable acts, including her Civil War service. It celebrated her as the exemplar of true womanhood: as a mother, she supported her family; as a citizen, she enacted her patriotic duty during the war. Little notice was paid to the photographic works she had produced for thirty years. But evidence survives in the form of photographs she stamped with her logo—surely with a touch of pride in herself and her work—"Mrs. W. A. Reed, Artist, Quincy, Illinois."

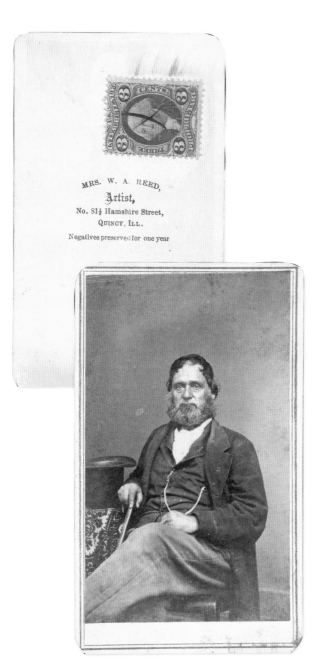

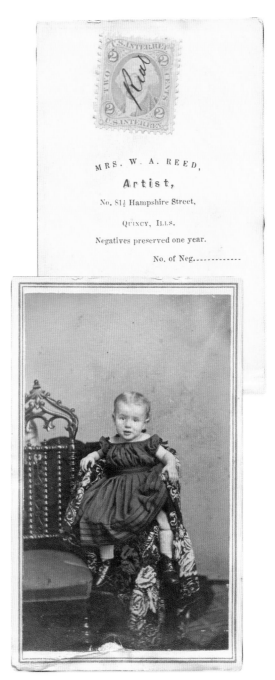

I-C-1 Candace Reed, Quincy, Illinois, *Seated Man*, *carte de visite* (revenue stamp on verso), 1864–66, private collection

I-C-2 Candace Reed, Quincy, Illinois, *Cute Baby*, *carte de visite* (revenue stamp on verso), 1864–66, private collection

The Tintype Trade:
From Martha Fletcher to Catherine Smith

Tintypes led to the democratization of image making, in that they broke the price barrier and opened photography up to widespread dissemination with their appearance in 1856.[24] To make one, the photographer applied an emulsion directly to a thin sheet of iron coated with dark lacquer or enamel, which produced a unique positive image. Tintypes could be called the first instant photographs, ready for the sitter in a few minutes. Daguerreotypes and ambrotypes were fragile, requiring a protective case that limited their portability. The tintype, by comparison, was far more durable and resistant to fading, and even when bent or scratched, it showed little trace of rust. It could be carried into battle without fear that it would be damaged or destroyed, and therefore made the perfect memento for the soldier. They came in a variety of usually small formats, from that of a *carte de visite* (2½ by 4 inches) down to the so-called gem or gem ferrotype, a tiny image measuring

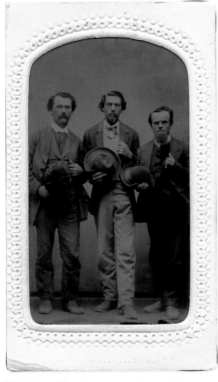

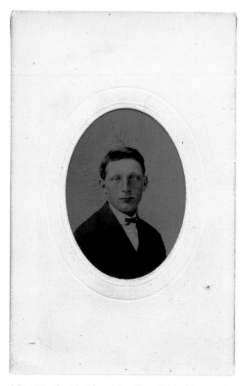

I-D-1 Mrs. Glover's Gem and Art Gallery (Mrs. C. L. Glover), Syracuse, New York, *Three Standing Men Holding Their Hats*, tintype, n.d., private collection

I-D-2 Martha Fletcher, Massillon, Ohio, *Young Man in a Bow Tie*, tintype, ca. 1859–70, private collection

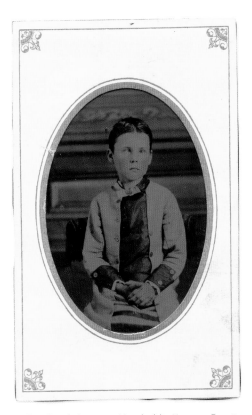

I-D-3 Sarah Larimer, Humboldt, Kansas, *Boy in Military Jacket*, tintype (with hand coloring), n.d., private collection

¾ by 1 inch. Mrs. Glover's Gem and Art Gallery attracted a trio of men who stood in a cluster, hats removed, and looked into the camera to make a tintype (fig. I-D-1). Since they demonstrate little family resemblance, they were most likely comrades who wanted to commemorate a trip together or perhaps just their friendship. Mrs. Glover advertised "pictures from 25 cents to $3.00 per Dozen," so we can assume that for a tintype she charged at the lower end of the scale.

Tintypes were usually presented in paper mounts with a rectangle or oval window mat that can be carried about or slid conveniently into an album. Also known as melainotypes or ferrotypes, tintypes were exposed directly in the camera and were, like daguerreotypes, reversed (as in a mirror). They generally display a narrow range of gray-black tones and lack the nuance and detail of other photographic formats. No tin was used in their manufacture, but rather the name implied the object's status as being of low worth, deceptive, and shoddy. A kind of homelier cousin to the daguerreotype, tintypes have nevertheless survived the test of time and offer a plentiful pictorial record of soldiers, celebrities, and even our own ancestors into the twentieth century. The prevailing stereotype was the cheap tintype, made by humble operators in poorly furnished studios for a lower-class clientele, but they had one of the longest periods of popularity of any early photograph type (they

remained in steady use into the 1930s). So, aesthetic snobbery aside, their place in the public's heart was ensured as a quickly produced photograph that was inexpensive, durable, and definitely more fun! Many respectable female photographers produced a ready supply of them for their clients.[25]

Martha Fletcher was among them. She had worked alongside her husband, Abel Fletcher, in Massillon, Ohio, initially as his assistant. After an accident with the developing chemicals left him blind in 1859, she took over their operations. She ran the business until about 1866, when her health began failing and a man named William Wilson took over the studio.[26] Throughout the 1850s and 1860s she made tintypes alongside a steady trade in *cartes de visite*, with her name and logo on the back.[27] Two examples of her tintypes—a young man dressed in jacket and bow tie and a young woman in a buttoned-up dark dress—convey the serious demeanor and respectability characteristic of other photographic formats (fig. I-D-2).[28]

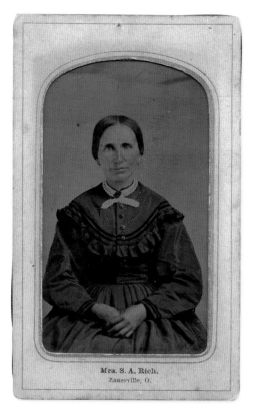

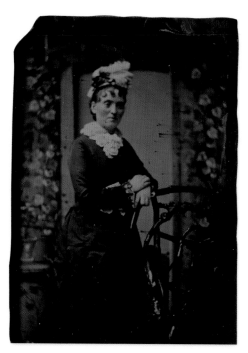

I-D-4 Elizabeth (Mrs. S. A.) Rich, Zanesville, Ohio, *Woman with Lace Collar*, tintype, 1883–87, private collection

I-D-5 Catherine A. N. Smith, New York, *Woman with Flower in Her Hair*, tintype (with hand coloring), 1890s, private collection

Mrs. A. E. Bennett, at her Photograph and Gem Gallery, photographed a woman wearing a dark dress with a white collar and a flower in her hair. For an extra fee she hand-colored the blossom that crowned her head in pink, and inserted the picture behind an oval frame with an embossed design, while Mrs. Larimer in her Photographic Rooms in Larimer, Kansas, tinted the cheeks of her young male sitter (fig. I-D-3). Mrs. Rich in Zanesville, Ohio, by contrast, opted for a more austere, monochromatic look but showed off the handsome dress of her middle-aged female sitter by showing her in half length (fig. I-D-4). There were multiple possibilities, and the cost was low enough that people felt free to experiment with poses and other details in a series of images.

Jumping to the 1890s, a woman's New York tintype studio is fleetingly mentioned in a collection of work by journalist Joseph Mitchell, known for his portraits of people and places at the margins of the city: one of his characters recalls going to "Mrs. C. A. N. Smith's Tintype Gallery at Broadway and Thirteenth, which was famous in its day."[29] Even this late in the century there is little available information on her, but her surviving images, such as that of a young woman wearing a stylish hat and leaning against an elaborately carved chair (fig. I-D-5), tell us that she had a good eye for figural composition as well as being skilled in the technology.[30] She affixed printed typographic labels to the verso of her tintypes, which served as advertisement:

Mrs. C. A. N. Smith	GEMS
Artist	18 for 25 Cents
840 Broadway	finished in ten minutes
Corner 13th St. New York	
Ladies Portraits a Specialty	All kinds of pictures made and copied
Reduced Prices	Good pictures taken in cloudy weather
Colored Crayon and Oil	Card Pictures in Clubs of Ten'
Portraits from $1 to $5	$1.00 per dozen, Imperials $2.00
According to finish and size	
Imperial $3 per dozen	
Cards $1.50 per dozen	
4 Card pictures 50 cts	
Imperials 25 cts each	

Although she tells us "Ladies Portraits a Specialty," she also accepted male clients, including a mustached man who held his young daughter on his lap for their double portrait. Surveying the thriving tintype businesses of these women, from Martha Fletcher in Ohio in the 1850s through Catherine Smith's busy trade in Greenwich Village at the turn of the twentieth century, reminds us of the flexibility of the tintype—its ability to respond to different people in diverse places over time.

MRS. M'OORE,

No. 421 Canal St.

N. Y.

Chapter II
CIVIL WAR ERA
Introduction

The rise of photography accompanied the Civil War (1861–1865). Military men leaving for the battlefields wanted to have their portraits taken, attired in their new uniforms, to share with loved ones back home. Simultaneously, their wives, mothers, and sweethearts had their likenesses taken as keepsakes for departing soldiers. War was a big boon for the field, and it was said that the "traveling portrait gallery" became "one of the institutions of our army."[31] Soon the US government recognized the popularity of the photograph as a potential income stream to support the war.

II-IN-1 Verso with revenue stamp of Matilda Moore, New York, *Civil War Soldier, carte de visite*, 1861–65, private collection

As the cost of the Civil War rose, the federal government passed a series of new taxes in 1862, which were to be paid by means of revenue stamps. All legal documents required revenue stamps, as well as a variety of goods such as playing cards, patent medicines, matches, and perfumes. Annual revenue from stamps amounted to more than $11 million by the war's end. An act of Congress on June 30, 1864, added a new tax on all "photographs, ambrotypes, daguerreotypes, or any other sun-pictures," to be paid by attaching a revenue stamp on the back of the photograph (fig. II-IN-1). The tax was two cents for a photo "with a retail value of not over 25c, 3c for a photo costing over 25c but not over 50c; 5c for photos costing over 50c but not over a dollar; and for each additional dollar or fraction of a dollar, another 5c."[32] Stamps were interchangeable, and there was no special stamp issued for photographs.[33] The photo tax, therefore, could be paid with any variety of revenue stamp costing the appropriate amount.

Cartes de visite usually cost about twenty-five cents—some were six for a dollar, and, later, ten to twelve for a dollar. Therefore two- and three-cent stamps are the values most commonly found on cdvs. If you wanted hand-tinted photographs, which were more expensive, then you paid a higher fee. Stamps found on photographs had a similar design: a portrait of George Washington in an ornate frame.[34] Photographers were supposed to cancel each stamp and record the date of the sale on the stamp. The majority used pen, although occasionally they used a hand stamp similar to a postmark. Some photographs bear stamps that were never canceled. Photograph galleries were diligent in making sure the revenue tax was paid, since there was a hefty ten-dollar fine for failure to do so.[35] Revenue stamps can still be found on the reverse of many Civil War–era photographs, which helps date them to ca. 1864–1866 (although the war ended in 1865, they were still in use in its immediate aftermath).

Civil War Soldiers through Female Eyes

In this section, we survey five portraits of men serving in the Civil War taken by female photographers working across the country: in Illinois, Maryland, New York, and Massachusetts. They all help demonstrate that, contrary to popular wisdom, women did indeed shoot soldiers on both sides of the conflict, at least in their photographic studios! Focusing on the confrontation between individual female operators and their military subjects, we can begin to appreciate that the record of the Civil War is far more diverse than previously recognized.

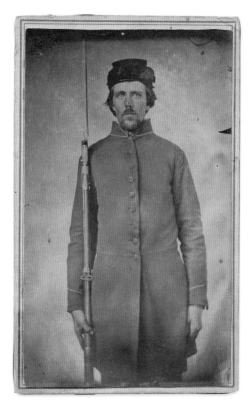

II-A-1 Mrs. O. Bennett, Hamilton P.O., Hancock County, Illinois, *Civil War Soldier, carte de visite,* ca. 1862–64, private collection

Mrs. O. Bennett, Hamilton P.O., Hancock Co., Illinois (fig. II-A-1)

Although this standing man seen in three-quarter length remains unidentified, we can deduce a fair amount from the details of the picture, probably taken in the early years of the war, ca. 1861–1862. He wears a standard US Army enlisted man's frock coat and holds what appears to be a model 1842 rifle musket. His rough-and-ready appearance suggests he is a western soldier, an observation borne out by the fact that he posed for Mrs. O. Bennett in Hamilton, one of the larger towns in Hancock County, Illinois. It is located in the far west of the state, where he, like most of the population, likely lived on rural farms. Sadly, little is yet known personally about Mrs. Bennett herself. In contrast to the more formally uniformed men we see in so many of the war portraits, this type of soldier was not always recorded for posterity—nevertheless, they were equally important to the outcome of the war.

Elizabeth Israel of Israel & Co., Baltimore, Maryland (fig. II-A-2)

This bearded man is in the Union army, a first sergeant identifiable by the three stripes with the diamond on his sleeve. Unlike some of the soldiers, who removed their hats for their portraits, he wears his forage cap. The other details of his attire are interesting, in that he wears a sash, belt, and gauntlets, while in his right hand he holds a sword, identifiable as an 1840 Ames foot officer's sword. Yet, he is not an officer. So perhaps the sword—like the sword belt and even the gauntlets—belonged to the photographer, who used them to accessorize her sitters, creating a more impressive look. The half column upon which he rests his left hand is another studio prop that lends further distinction.

Born in the West Indies and likely Jewish, Elizabeth Israel had made her way to Baltimore and was a photographer working in the family gallery of Israel & Co. Beyond that, little data has been located about the Israels.[36] Given their location on Baltimore Street, we can place them within the city's photographic district, where nearby firms included Mosher's Galleries at 406 W. Baltimore Street and P. L. Perkins at 205 and 207 Baltimore Street.[37] Politically, their situation was extremely complex, since Maryland was a slave state and was one of the border states straddling the North and South. Despite popular pro-Confederate sentiment, however, Maryland would not secede during the war. The third-largest city in the US at the time, Baltimore was strongly Unionist and sent many recruits into battle, including the US Colored Troops, but simultaneously many of the city's young men crossed Confederate lines. Soldiers from both sides, in fact, frequented the Israel Gallery, with everyone from enlisted men to officers on both sides being photographed in like manner.[38] They may even have dropped in at the same time, precipitating a few fistfights.

MARY, 12 North Front Street, Kingston, New York (fig. II-A-3)

This sitter wears a Union army uniform of sky-blue trousers with a broad blue stripe down the outer seam—appropriate to a sergeant—along with an enlisted man's sack coat and blouse. The cap that sits on the table beside him is a commercially purchased kepi. He is a first sergeant, most likely in the 120th New York Regiment, in the 1st and 2nd Brigade, 2nd Division, 3rd Corps, from October 1862 to March 1864. Since the 120th Regiment was organized at Kingston, New York, this man was probably from the area and stopped off in the studio before heading off for duty. His regiment was considered among the finest fighting units in the Union army and saw action in most of the major battles of the war both in the eastern and western theaters, so we can only imagine what horrors he beheld after this photograph was taken.[39]

In this case, the photographer identified herself on the verso of the card only as "MARY, Photographer and Artist in Water Colors." The fact that she mentions her work in watercolors suggests that she also was the gallery colorist, retouching the photographs with hints of flesh tones or highlights on the clothing. Although she provides no surname, research indicates that she was the wife of George A. Vallet, a leading photographer in Kingston from ca. 1850 to 1870. Mary herself was born ca. 1838 and was active from about 1860 to 1866. Given the paucity of information about this woman and the rarity of an American female photographer identifying herself solely by her first name, we can only guess at her motivation. Perhaps she was eager to come out from behind the shadow of her husband and asserted her independent identity as Mary. So far, only a few works by her have been located.[40]

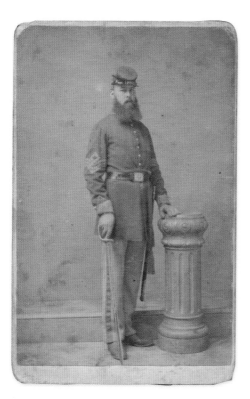

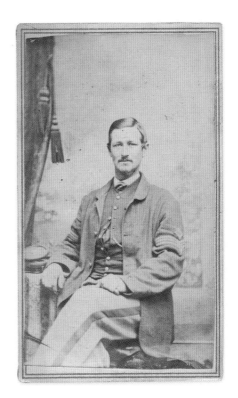

II-A-2 Elizabeth Israel & Israel Co., Baltimore, *Civil War Soldier, carte de visite*, 1861–65, private collection

II-A-3 Mary (Mary Vallet), Kingston, New York, *Civil War Soldier, carte de visite*, ca. 1862–64, private collection

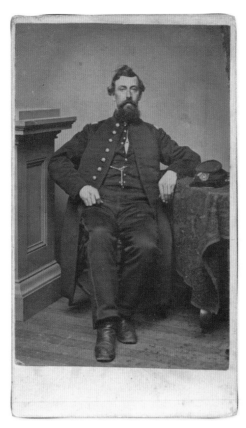

II-A-4 Helen F. Stuart, Boston, *Civil War Soldier,*
carte de visite, ca. 1861–65, private collection

Mrs. Helen F. Stuart, 258 Washington Street, Boston, Massachusetts (fig. II-A-4)

Around 1862, this handsome bearded gentleman entered Helen Stuart's studio to have his photograph taken. His single-breasted frock coat, dark trousers, and shoulder boards identify him as a company-grade officer, either a lieutenant or captain. More specifically, he belongs to the 12th Massachusetts Regiment, which was called the Webster Regiment, after its colonel: the son of orator and politician Daniel Webster. Looking more closely at the front of his cap tossed on the table beside him, it is evident that an infantry bugle encircles the number "12," further indicating that it was a privately purchased forage cap. Clearly, Stuart attracted some distinguished clients to sit in her chair.

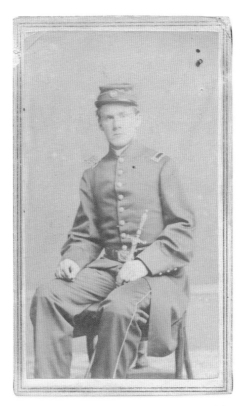

II-A-5 Matilda Moore, New York, *Civil War Soldier*, *carte de visite*, 1861–65, private collection

Mrs. Matilda Moore, 421 Canal Street, New York (fig. II-A-5)

This seated figure is a first lieutenant wearing a regulation frock coat and trousers with a light-colored pipe down the outer seam. Since New York State specified buff-colored piping, this detail tells us he was a New York staff officer. He wears a dark-blue cap called a kepi with a lower band of dark green decorated with a gold bullion wreath around the letters "MS," and between his legs he holds a medical sword (recognizable by the design on the hilt). The initials and sword identify him as part of the medical service.

Working in lower Manhattan, Matilda Moore positioned herself in a neighborhood through which a good deal of military traffic passed. With what time he had in New York City, this officer found his way into her studio, whether upon the recommendation of another client or a chance visit when he spied her sign walking down Canal Street.

Spirit Photography & the Cult of Memory in Boston:
Helen F. Stuart & William H. Mumler

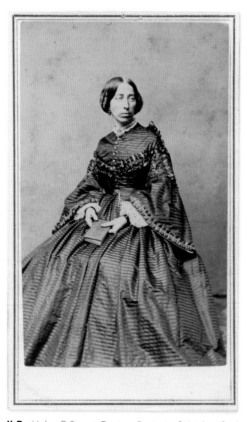

II-B-1 Helen F. Stuart, Boston, *Portrait of Unidentified Seated Woman Holding a Book, carte de visite*, ca. 1860–65, private collection

Helen F. Stuart (1832–1912) worked as a photographer in Boston in the 1860s. Much of the information we have about her is gleaned from her photographs and city directories, which tell us that in 1861, Stuart set up a studio in her name at 258 Washington Street. Advice manuals of the day enumerated some of the requirements needed for such an undertaking, including "a preliminary education in the science of photography, a knowledge of chemicals used, and a few hundred dollars. It costs from forty to seventy five dollars to build a good skylight."[41] A *carte de visite* of an unidentified woman (fig. II-B-1) that she produced soon after setting up shop indicates that she had what it took. The cdv yielded a standardized format on a small scale, but her technical proficiency is evident in her clear, sharp image with a balanced range of tones. She also demonstrates a grasp of the chemistry involved, since her image remains readable while many from this era have turned foggy.

Boston boasted many photographers, including James Black, the first to take an aerial photograph of the city. His pictures of Boston from the air show Washington Street cutting across the lower third of the picture, suggesting it was already a crowded area when Stuart set up shop. Black's photograph of a stretch of Washington Street confirms Boston's reputation as the center of economic activity and technological innovation by the time of the Civil War. It tells us that Stuart's photographic gallery was located in a commercial district alongside printing establishments and bookshops. As this standing portrait of a woman in her satin dress (fig. II-B-2) indicates, Stuart posed her clients against pillars and beside stuffed chairs: common studio props that projected the figure into a domestic setting, in a style emulating painted portraits.

The prestigious local firm of Southworth & Hawes was a pioneer in daguerreotype photography, with clients such as Harriet Beecher Stowe and Jenny Lind, and set the standard for practitioners who followed them.[42] But the city quickly evolved a broad spectrum of photographers: from those who catered to the rich and famous to those happy to have walk-in customers from the lower end of the socioeconomic scale. This class difference was mirrored in everything from technical equipment to gallery decor. As one author advised, once the

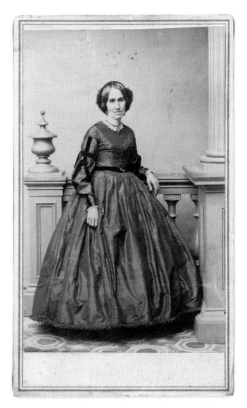

II-B-2 Helen F. Stuart, Boston, *Standing Woman Wearing a Satin Dress, carte de visite,* ca. 1860s, private collection

photographer rented the studio, then "the instruments and chemicals must then be purchased, and these will range in price from one hundred to one thousand dollars, the latter being the cost of an outfit for a handsome gallery, with furnishings, scenery, and all modern equipments [*sic*]."[43] We can imagine Mrs. Stuart operating in the middle range of this economic scale, attracting respectable folks—from newly inducted soldiers to mothers with young children—for whom having a photograph taken was something of an event.

Women and children were considered the proper domain of the female photographer's studio. They would have their pictures taken as a keepsake to give to sons, brothers, or fathers going off to the battlefields. But during the Civil War—when Boston sent over 26,000 men to serve in the armed forces—soldiers, too, came to be portrayed by Stuart. They wanted to have mementos to leave behind with family as they set off for combat and possible death.

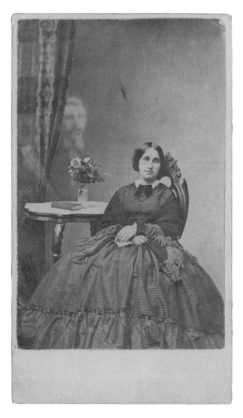

II-B-3 Helen F. Stuart, Boston, *Woman Seated at a Table with a Male Spirit, carte de visite*, ca. 1865, William L. Clements Library, University of Michigan

Stuart began her career as a "Hair Jewelry Manufacturer" and continued to advertise it on the verso of photographs. Often called mourner's jewelry, such items were made from the hair of the deceased and contributed to the memorializing of a loved one. Her creation of hair jewelry connected her with those who had recently lost loved ones, and therefore the popular culture of memory and death during the war years and its aftermath.

There is yet another dimension of this visual culture in which she participated. Records indicate that William H. Mumler worked in Stuart's studio. He gained notoriety for his spirit photographs—most famously in his portrait of Mary Todd Lincoln with the ghostlike presence of her slain husband hovering behind her. He often used this joint photographic format, which united the bereaved and the deceased in a single image. Mediums—the majority of whom were women—enabled the appearance of the "extra" of the deceased, whom the spirit photographer then captured on the glass plate negative (fig. II-B-3). Mumler has traditionally been credited with "discovering" this art in 1861, and while it was known that he created these ghostly mementoes in Stuart's studio, she had been denied a larger role in their creation. But further investigation reveals that Mumler remained until 1865 in her Washington Street studio, where she too, at least occasionally, took such images and should be recognized as a key instigator—and perhaps even the originator—of spirit photography.[44] Linked to some of the same ideas that led to the founding of Spiritualism, Stuart's hair jewelry, photographs of soldiers and loved ones, and spirit photography all demonstrate the foundational role of women within the narrative of personal mourning rituals in the United States in the 1860s and beyond.

Gallery of Kentucky Notables: Mrs. James O'Donoghue

In the late 1850s, James O'Donoghue and his wife determined to open a photography studio in their hometown of Frankfort, Kentucky, with James doing the camerawork and his wife managing the day-to-day affairs. Situated in the eastern part of the state, Frankfort is the capital of Kentucky and therefore a lively site of political activity. It made good sense to situate their establishment in proximity to the seat of government to ensure a robust clientele. The logo they created made this location the selling point: "Mrs. O'Donoghue's Art Gallery, opp[osite] Capitol Hotel, Frankfort, Kentucky." This well-known hotel was built by the city in the 1850s to provide comfortable accommodations for Kentucky General Assembly members and others acting on official state business.[45] The O'Donoghues were perfectly positioned to attract representatives, senators, and other lawmakers to sit before their camera. Since many of these gentlemen (there were no female members in those days) were boarding in Frankfort, far away from the counties that elected them, they needed portraits of themselves to send to their constituencies back home. The impressive list of historical figures who patronized their gallery includes William Lindsay (1835–1909), who practiced law in Frankfort before joining the Union army during the Civil War and later became a US senator from Kentucky.[46]

The O'Donoghues eagerly documented these distinguished members of the State House and Senate—partly a matter of economics, since they provided a dependable customer base. But the couple saw themselves not merely as photographers shooting local sitters, but rather as regional historians shaping a gallery of portraits of Kentucky notables. This decade, after all, witnessed great political upheaval accompanied by intense patriotism,

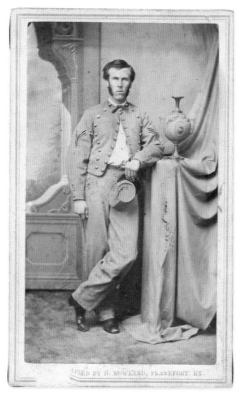

II-C-1 Mrs. James O'Donoghue, Frankfort, Kentucky,
Kentucky Guardsman, carte de visite, 1861–65

stimulated in part by visual imagery. Allegories and scenes of historic events were two common themes, but more effective were portraits of people who contributed to the good of the country. In this climate, photographs took on new significance, partly due to the reputation of Mathew Brady, who shaped the role of the photographer as national historian, recording everyday citizens alongside famous figures. Mrs. O'Donoghue was undoubtedly aware of Brady's creation of a vast pictorial archive documenting the faces of great men as proof of their great acts, a photographic pantheon that instructed Americans in a love of country.[17] Surely these ideas were on the Kentucky photographers' minds as they shot picture after picture of the political leaders of their state. Likely hung as a group in their gallery, the display of the faces of these regional dignitaries constituted a shrine to local heroes, inspiring loyalty to their community at a time when outside forces threatened to drive them apart.

On April 12, 1861, Confederate troops fired on Fort Sumter in the harbor of Charleston, South Carolina, initiating the Civil War. As the capital of Kentucky, Frankfort experienced a constant military presence. But the city was also a Union army garrison during much of the war, as well as the scene of several military skirmishes.[18] In August 1862 it became the only pro-Union state capital occupied by the Confederate army. Even

though the Confederate stay there was only temporary, it meant that soldiers from both armies—Union and Confederate States of America—found their way into the operating room of the O'Donoghue gallery, an extremely unusual development in Civil War photography. They photographed both CSA captain William Johnson Stone of the 2nd Kentucky Regiment and a Kentucky Guardsman (fig. II-C-1), identified by his uniform as belonging to the Union army. One can only imagine the conflicted feelings that must have arisen in the camera operator, posing infantrymen from both sides of the conflict.

When Mrs. O'Donoghue found herself a widow in 1865 with the photographic studio solely in her hands, she opted to manage the business under her own name and hire an experienced male photographer to produce the portraits. "Mrs. O'Donoghue, widow of the late James O'Donoghue, Photographic Artist, begs to inform the citizens of Frankfort and vicinity that the business heretofore carried on by her late husband will be

D. ROWLAND, Photographer, Frankfort, Ky.

II-C-2 D. Rowland, photographer at Mrs. James O'Donoghue's, opposite Capitol Hotel, Frankfort, Kentucky, *Man Wearing Bow Tie and Watch Fob* (identified as "A[lfred] Kendall of Williamstown, Kentucky" in pen on verso), *carte de visite*, ca. 1860s, private collection

continued under the management of first class operators," an announcement in the local paper explained. "The very liberal patronage bestowed upon Mr. O'Donoghue up to the time of his decease she hopes still to receive and to merit which will be her constant endeavor."[49] The postscript added a polite but pointed reference to debt collection: "N.B. Mr. David C. Rowland is authorized to collect all accounts due to the late Mr. O'Donoghue."[50]

After that point, work emerging from the gallery bore the inscription "D. Rowland, photographer, at Mrs. O'Donoghue's Art Gallery, opp. Capitol Hotel, Frankfort, Kentucky." This includes a cdv that records the visage of Alfred Kendall (1811–1876) of Williamstown—a state representative in the 1850s—complete with the watch fob that was the male symbol of respectability (fig. II-C-2).[51] He also was prompted to take more-casual images, including a group portrait of five women seated on the ground against the painted backdrop of a landscape (fig. II-C-3).

David C. Rowland (1842–1882) was born in England and moved to Kentucky, where he married and raised a family. Records indicate that Rowland had been working in the O'Donoghue gallery since 1862, perhaps initially renting space and subsequently working under the management of Mrs. O'Donoghue. Tracking him through newspaper records reveals that in 1872, reference was made to the D. Rowland Gallery, still in the same location, but by 1873 he had closed his business there and moved to the Burke Hotel. Upon his death in 1882 he was buried in the Frankfort Cemetery. When and how he and Mrs. O'Donoghue parted company is not known, but during the time of their collaboration in the 1860s, he contributed substantially to the goal of creating a gallery of Kentucky notables.

II-C-3 D. Rowland, photographer at Mrs. James O'Donoghue's, opposite Capitol Hotel, Frankfort, Kentucky, *Five Women*, *carte de visite* with hand coloring, ca. 1860s, private collection

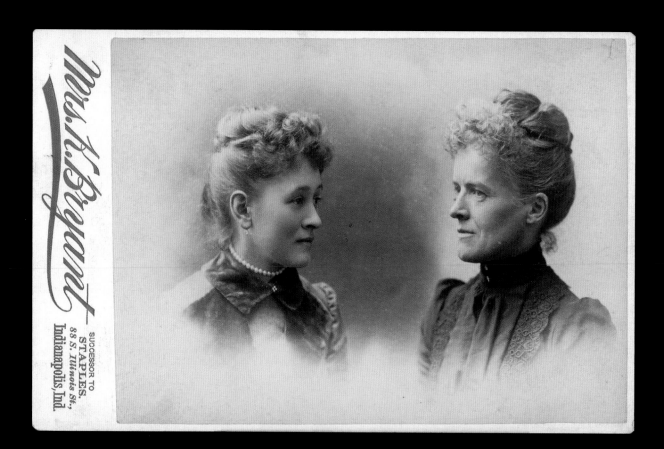

III-IN-1 Kate Bryant, Indianapolis, Indiana, *Mother & Daughter*, cabinet card, ca. 1890, private collection

Chapter III
Family Matters
Introduction

Immediately upon photography's invention, it became the indispensable hand-maiden to American family life. Today we rely on photographs to record the details of specific life-defining events such as births, graduations, and weddings. In the nineteenth century, by contrast, the existing technology did not allow the photographer the ability to record births or the taking of vows as they were happening. Instead, she recorded the appearance of an individual around the time that event took place, with emblematic references to help identify it, such as a christening gown or bridal veil. Flipping through the pages of a family album allows glimpses of the four stages in the lives of family members: birth, youth, middle age, and old age. They also provide psychological insights into family relations. One striking photograph juxtaposes the heads of a mother and daughter facing one another, the profiles revealing both family resemblance and strong emotional affiliations (fig. III-IN-1). A substantial number of photographs of sister duos have come down to us, underscoring the importance of the intertwined lives of female siblings within the larger family unit, conveying a mix of competition and cooperation. Husband-and-wife couples frequently headed to the photographer's studio, beginning with their engagement and wedding, then continuing through anniversaries at regular intervals into old age.

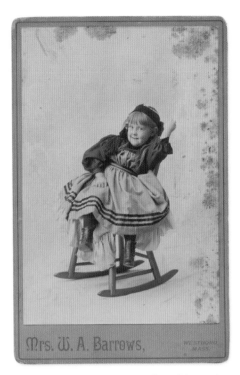

III-IN-2 Mrs. W. A. Barrows, *Little Girl Seated in a Chair*, cabinet card, ca. 1885, private collection

Babies accounted for a substantial percentage of studio portrait business, prompted in part by promotional literature advising mothers that they would be neglecting their maternal duty if they failed to photograph their offspring early and often. Babies on bearskin rugs, propped up on ungainly wooden furniture, or smiling mischievously from a rocking chair (fig. III-IN-2) all document Victorian children. Their sad counterparts are the postmortem photographs that were often the only record a family had of a deceased child in an age of high infant mortality. Pictures of babies and young children were, not surprisingly, considered the domain of the female photographer. Popular cartoons mocked the inability of male photographers to quell the screams of their youngsters, and celebrated the ability of their female colleagues to coax a calm demeanor and even a smile from their small charges. It may have been the sole area of the profession in which women were championed as superior to men. What we may well ask is the fate of all these photographs—how did they come down to us in such numbers? Many were placed into albums bound in velvet or leather and hinged together, sometimes even including a lock to keep the contents from prying eyes. These albums were kept prominently in a stand or on a tabletop in the parlor and were opened up to display for guests as a form of shared entertainment and source of family pride.

Wedding Bells

Throughout history, marriage between two people has generated many rituals.[52] But from the moment photography came onto the scene, it became essential to the process of taking one's vows, as newlyweds seized on its potential for capturing memories of the special day. Tradition has it that the history of wedding photography began with Queen Victoria and Prince Albert, although in truth, when they married on February 10, 1840, no photographers were around (the medium had been "invented" only in 1839). So fourteen years later they reenacted the moment for Roger Fenton to record. Then, as now, the weddings of British royalty were highly newsworthy, so as Fenton's photographs circulated widely, they triggered the trend for wedding photography.

In the 1850s and 1860s, wedding pictures were not generally taken at the time of the ceremony. Given the limitations of lighting and the difficulty of transporting heavy cameras and developing materials, spontaneous on-the-spot pictures were nearly impossible. Certainly, people of middling economic means could not afford a photographer on-site. So immediately before or perhaps just following the big day, husband and wife headed to the photo studio dressed in their dark-colored Sunday best, sometimes with a bridal veil or some flowers to

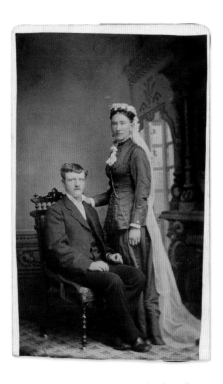

III-A-1 Pauline Nilsson, Cambridge, Illinois, *Marriage Portrait with Man Seated and Woman Standing, carte de visite*, n.d., private collection

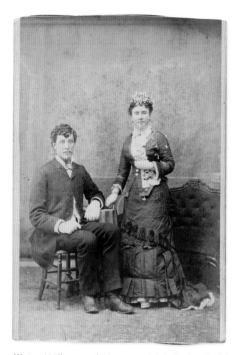

III-A-2 William and Margaret J. McGinley Fields, Lyons, Iowa, *Marriage Portrait with Man Seated and Woman Standing, Wearing Crown, carte de visite*, n.d., private collection

reference the event and add a touch of flair to the image (fig. III-A-1). When posing couples, photographers adopted the convention that the man was seated and the woman stood beside his chair with her arm often placed on his shoulder (fig. III-A-2). Sometimes a couple would head to the photographer upon their engagement to commemorate the event. The enterprising Kansas-based photographer Rosa Vreeland even suggested that if you were unable to attend a wedding in person, then a photograph could provide your surrogate:

> A young lady in London who was crowded by engagements could not attend the wedding of a dear friend. She had her own photograph taken and sent it together with her good wishes to the bride on the eventful day. This is a matrimonial invention that is worth something, and Mrs. Vreeland Whitlock rejoices and is exceeding glad that she has lived to see this day. Let all photographers rejoice, for the fashion set by the London lady will be followed numerously and the picture-taker's business will be good from this time forth.[53]

As the demand for wedding pictures grew, these events spelled big profits for photographers, who used a variety of strategies to induce customers to use their services. Virginia Hartley Stiles—who was a partner in a Chicago photographic business—may have been the creator of this ad that ran in 1890:[54]

IS MARRIAGE A FAILURE?

You would not think so could you see the lovely brides and happy bridegrooms that throng Hartley's Studios, eager to secure a Crayon or Cabinet portrait of their wedded bliss.

Crowded as are our parlor there's room for YOUR fair bride,

The joy of all your hours, your comfort and your pride!

Then seize the lovely shadow o'er the substance fade,

And bring your precious jewel, in loveliness arrayed;

Suspend her crayon'd beauty in the parlor of your home,

A shrine for your devotion, and in your heart a poem.

Marriage may prove a failure, and e'en the portrait too.

Unless it prove a love and joy forevermore for you!

In CRAYONS or in CABINETS be sure and get the best.

There are none so fine as HARTLEY'S in the East or West.

Artistic skill and excellence there evermore combine;

And bring YOUR bride and come yourself to No. 309.[55]

Conflating marriage with the workings of Hartley's studio, she established photography as the corollary to wedded bliss. Like Vreeland, many other female photographers in the Midwest, including Martha Clizbe (1864–1906) in Reedsburg, Wisconsin, created portraits that conveyed a sense of harmony between man and woman (fig. III-A-3). With this proliferation of pictures, the wedding album was born.

Sometimes the betrothed would opt to have dual tintypes made that were then affixed to a preprinted marriage certificate as an alternative way of documenting the event. In the 1870s, Boston-based lithographer Louis Prang printed blank forms with decorative lettering and two frames ready for the insertion of the photographs, and spaces for the presiding minister or justice of the peace to inscribe the relevant details. A rare example of such a certificate for African Americans, that of August Johnson and Malinda Murphy, who were married on July 9, 1874, survives in the collection of the National Museum of African American History & Culture. "Marriage Certificate" is printed across the top, flanked by two allegorical figures. The husband's bust-length portrait was inserted in an oval frame on the left, with his name added in script to the blank line below: "August L. Johnson." At right, the wife's photograph appears in the same format and is identified as "Malinda Murphy." The text below reads "Were this ninth 9th day of July 1874 legally joined by me in MATRIMONY / In presence Charles Bannister [and] Joanna Murphy to which I hereby / Certify Abraham Cole."[56] As the truthful recorder of the age, photography provided a perfect witness to the union between man and woman.

Only in the late nineteenth century did couples appear in photographs in their formal wedding attire. By the turn of the century, technology facilitated multiple shots with little time in between, allowing for the bride

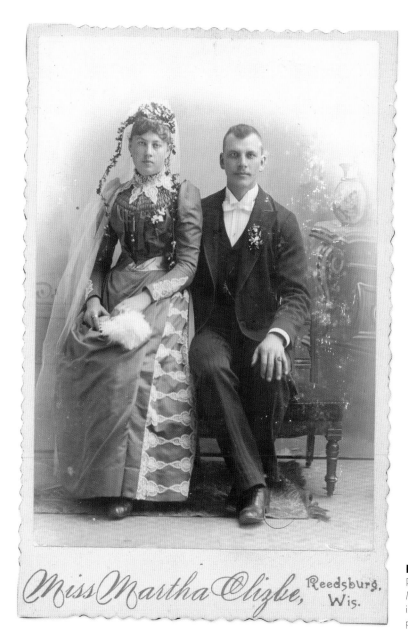

Miss Martha Clizbe, Reedsburg, Wis.

III-A-3 Martha Clizbe, Reedsburg, Wisconsin, *Marriage Portrait*, cabinet card, ca. 1895–1906, private collection

and groom to appear in more than one pose and for the entire wedding party to be photographed, including the groomsmen and bridesmaids. The tradition of having the brides be accompanied by her bridesmaids goes back to ancient times, when the maids were required to wear exactly the same dress as the bride and to heavily veil their faces. This was done to confuse jealous suitors and evil spirits so they could not single out the bride and harm her. A wedding anniversary does not have as specific a symbolism or iconography as the original event, but given the existence of a substantial number of cdvs and cabinet cards of older couples photographed together, it seems likely that they were intended as pictorial celebrations of the longevity of a marriage.

The Booming Baby Business: Emily Stokes of Boston

Often typecast as "baby photographers," women found their bread and butter capturing the likenesses of crying babies and squirming children. They were thought to have special skills: devising ingenious ways of keeping them still, coaxing a pleasing expression, and snapping the picture as quickly as possible. The popular press was brimming with cartoons and caricatures of male photographers who were miserable failures in this line of work (fig. III-B-1). Consider the example of the highly renowned and technically proficient male photographer Pirie MacDonald. In an early photograph by him of two children, an afterimage is visible, echoing the forms of their bodies and suggesting that they were moving when he pressed the shutter (fig. III-B-2). This flaw would seem to support the stereotype that men were less successful in photographing young people. Although one example certainly does not prove the rule, in MacDonald's case it is borne out by the fact that shortly after this he gave up photographing women and children and devoted himself to "men only." Clearly the women had their work cut out for them.[57]

With small babies, the challenge was how to keep them still and make them look natural in the portrait. Mrs. R. A. Goodwin of St. Johnsbury, Vermont, created an intimate pairing of a mother with her child's face nestled close to hers (fig. III-B-3). Miss Lucretia Gillett of Saline, Michigan, photographed Archer C. Davenport (whose name is penciled in on the verso of the card) in his grandmother's lap (fig. III-F-1). In Danbury, Connecticut, Mrs. Folsom (fig. IV-A-1) posed an especially cute baby dressed in a Christening gown, perched on a chair covered with a printed textile. Miss L. J. Stearns of Honesdale, Pennsylvania, acquired a small posing chair—rather like

"YOUNG HIGGINS."

III-B-1 Artist unidentified, *Man Trying to Take Baby Portrait*, cartoon, popular press, ca. 1870s

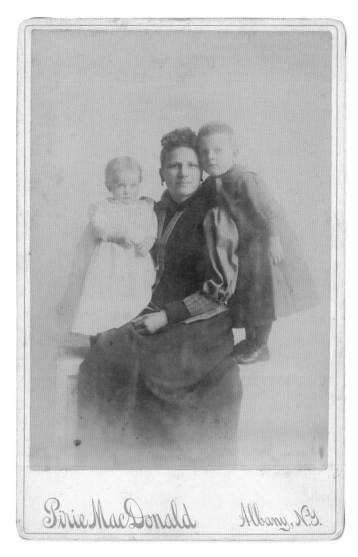

III-B-2 Pirie MacDonald, *Mother and Two Children*, cabinet card, 1880s, private collection

an upholstered high chair—to shoot her little subjects. White fur rugs were a common prop for children's pictures in the late nineteenth century, as used by Brooklyn's Mrs. J. Wolf and New York's Mrs. W. A. Robinson, who added texture to her image by posing two siblings—one an infant and the other about one and a half years old—on a fur rug tossed on a chair.[58] Miss Clark (first name unknown) of Port Byron, Illinois, managed to arrange two young children on either side of the family dog while all three held their poses.

But we should look to Emily Stokes, whom Frances Willard in her book *Occupations for Women* (1897) singled out, as excellent in this line of work: "Mrs. Emily Stokes of Boston is an example of what a woman may accomplish in photography," Willard wrote. "When compelled by misfortune to give up her London home, she came to America to begin life among strangers." The author saw in Stokes's triumph over adversity the role model for her American readers: "Having been associated with enthusiastic photographers in England, and believing that the position could be filled by women as well as men, she resolved to enter the field as a professional." She owed her success, in Willard's view, to her dedication to babies and children: "For sixteen years she has aimed to produce the true child portrait. She has conquered difficulties and is an enthusiastic and successful artist."[59]

Her portrait of Katharine Weems in her christening gown (fig. III-B-4) is an example of her technically ac-complished work in this genre. Many of the journals recommended this work as especially lucrative, since if the photograph produced a pleasing likeness, then the mother was likely to return to have pictures taken annually. This was apparently the case for Stokes, who documented successive phases of Weems's childhood. Women were the primary consumers of photographs, bringing family members to the studio and organizing payment out of household money.[60] They placed these precious pictures of their beloved children into albums that were proudly displayed in their parlors, and preserved as records of the family history alongside their bibles.

Stokes wisely situated her studio on Boylston Street, occupying several different spaces on the same busy thoroughfare in the 1880s and 1890s. The success she enjoyed as a photographer was due in no small part to her address in a fashionable neighborhood. Socially connected and wealthy clients were more likely to frequent her here, but of course the prime locations also spelled high expenses, since rent was one of the largest expenses in the budget of a typical studio.[61] Ever ambitious, she could not rely on location alone to attract customers.

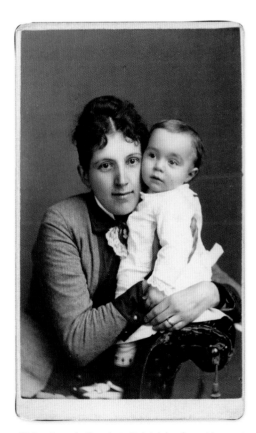

III-B-3 Rose A. Goodwin, Saint Johnsbury, Vermont, *Mother and Child, carte de visite,* n.d., private collection

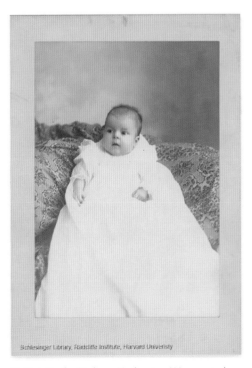

III-B-4 Emily Stokes, *Katharine Weems in her Christening Gown,* cabinet card, ca. 1880s, Radcliffe College, Harvard University

"At Mrs. Emily Stokes's photographic rooms, Pelham Studios, 44 Boylston Street, there is to be seen a painting by John Sell Cotman, dated 1877," we read in the press. "Cotman . . . belonged to what was called the 'Norwich school.' . . . The picture is the property of Mr. W. Davis, the picture framer, Washington street."[62] This notice tells us first that she was eager to elevate her status by associating her studio with fine art—in this case a famous nineteenth-century British artist she would have known from home. But it also reminds us that she was part of the visual-arts community in Boston, which included framers, artists, and photographers, all of whom worked together. Stokes aimed to link herself with the broader cultural realm rather than the business community. Clearly she wanted to be remembered as more than a baby photographer.

Emily Stokes appealed to Boston's elite, a practice she had started in London before her move to the US. "My patrons," she wrote, "are among the very best of our citizens, people of culture here and in England."[63] Before the turn of the century, her studio also became a preferred site for educated women to have their pictures taken, including an increasing demand for class portraits of female college graduates. She recorded the young women graduating from Wellesley College, and portrayed well-known women, from the writer and activist Abby Morton Diaz to Helen Keller. The portrait of Keller was done when she was a student at Radcliffe College around 1902, the year she published the autobiography that made her famous.

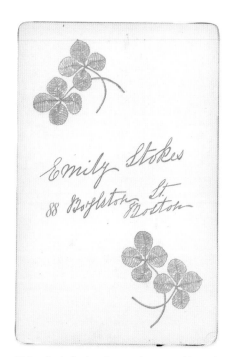

Stokes devised a logo perfectly suited to her cultured clientele (fig. III-B-5). Although printed, her signature appears as if handwritten in cursive, all done in gold leaf and accompanied by her distinctive floral emblem. By these means she personalized and enriched each photograph for her socially elite clientele. But while she saved their likeness for posterity, she also fashioned a distinctive logo to brand herself and thereby ensure that her identity as the photographer would also survive.

III-B-5 Emily Stokes, *Logo*, cabinet card (verso), 1880s, private collection

"Remember Me": Postmortem Photographs of Babies

From the invention of the daguerreotype, photography became part of the memorial process. While for twenty-first-century observers the sight of faded images of tiny corpses lain in coffins or held in their mothers' arms strikes us as macabre, Victorians viewed them as serene and beautiful documents, valued as their last glimpse of a loved one. Prior to the invention of photography, the task of capturing the deceased young one fell to painters, who were summoned to the grieving parents' house at all hours of the day or night and in every kind of weather to record the likeness in oil on canvas. Long Island painter William Sidney Mount wrote of his distaste for this kind of work, for which he charged a much-higher price (as much as double) than for a living sitter. But once the camera came along, it offered a faster and more affordable alternative. Soon it was regarded as the more effective medium in evoking the dead. A photograph sets up a direct relationship with

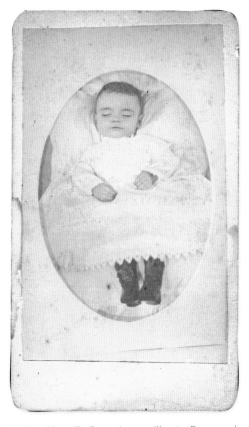

III-C-1 Clara E. Gore, Lacon, Illinois, *Deceased Baby, carte de visite*, ca. 1860s, private collection

the deceased, providing an imprint of her or him. The camera operator engaged in a physical relationship with the body, manipulating and coaxing it into the desired position. The painter, by contrast, was more removed; she or he recorded the face of the deceased on the spot but was free to imagine and idealize the body's position without the necessity to handle it.[64]

"The other day I was called upon to make a negative of a corpse," reported one photographer, who advised his fellow practitioners to move the body closer to the window to make use of natural light. The dead subject offered the advantage of being immobile, but was soon stiff and difficult to manage, so it was best to advise friends and family "to leave the room to you and aids, that you may not feel the embarrassment incumbent should they witness some little mishap liable to befall the occasion."[65] Mindful that the grief-stricken family did not want the photographer around their home long, Mr. and Mrs. Charles Waldack advertised: "Post Mortem pictures taken with dispatch."[66]

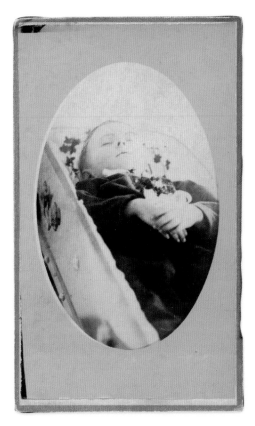

III-C-2 Miss A. L. Paulus, Fredonia, Wisconsin, *Deceased Young Boy in a Dark Suit*, *carte de visite*, ca. 1860s, private collection

The posing of the eyes offered a particular challenge. Sometimes they were propped open, but at other times they were left shut so that the reclining figure appeared as if at rest. As a last resort, "proper retouching should remove the blank expression and stare of the eyes." High infant mortality rates and a lack of effective treatments for childhood diseases meant that parents had to prepare for the unthinkable by recording the likeness of a son or daughter, an obligation that often fell to the mother. "Remember me," leading photographer Mathew Brady urged; "you cannot tell how soon it may be too late."[67]

Type-cast as baby photographers, women were often called upon to perform the sad duty of taking a picture of a recently deceased child. Mrs. M. E. Gore of Lacon, Illinois, showed one baby dressed all in white but for dark footwear laid out on a bed, leaving the viewer to comprehend the image as the visual representation of the "last sleep" (fig. III-C-1). Gore shot the portrait with a *cartes de visite* camera that reproduced multiple copies, allowing the mother to insert one in the home album and still have sufficient copies to distribute among family and friends. From 1850 to 1900, the formal conventions of postmortem photographs evolved. Initially, they depicted death as if it just occurred, as Mrs. Gore did: the body is isolated and the focus is on the face, with little or no detail for context. Later, the baby was shown cradled in the mother's arms, propped up with a favorite toy or reclining with a religious emblem. Miss Al. L. Paulus of Fredonia, Wisconsin, posed one unidentified little boy dressed in a dark suit in a white coffin with a sprig of flowers between his crossed hands (fig. III-C-2). White clothing, sprigs of flowers, and white coffins all evoked the idea of an innocent angel, reassuring the parents they were safe in heaven.

Today we are completely saturated with images, but the words of Oliver Wendell Holmes remind us of the state of visual culture in the nineteenth century, when a single image of a loved one was so rare and so dear:

> It is hardly too much to say, that those whom we love no longer leave us in dying, as they did of old. They remain with us just as they appeared in life; they look down upon us from our walls; they lie upon our tables. . . . Our own eyes lose the images pictured on them. Parents sometimes forget the faces of their own children in a separation of a year or two. But the unfading artificial retina which has looked upon them retains their impress, and a fresh sunbeam lays this on the living nerve as if it were radiated from the breathing shape. How these shadows last, and how their originals fade away![68]

Sisters

Sisters share a complex relationship, especially if they are close in age. Their bonds and modes of interaction are established early on and usually endure throughout their lives. In biological terms, their relationship might be termed a symbiosis: interaction between two different organisms living in close physical association, to the advantage of both, especially if they were twins (fig. III-D-1). The history of nineteenth-century art and literature embraces the intricacies of well-known sister dyads, including Emily and Lavinia Dickinson or Berthe and Edma Morisot, of whom art historian Anne Higonnet observed:

> Behind every great woman there is another woman. Perhaps the only common denominator among nineteenth-century women of outstanding public achievement is their private bond to a female relative, almost always a sister, very often a sister with considerable talent of her own. It remains a subject of fascination that one family produced three exceptional writers: Charlotte, Anne, and

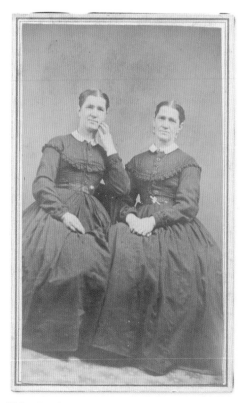

III-D-1 Sarah Ann Landis (Mrs. S. L.) Stebbins, artist, Corry, Pennsylvania, *Two Sisters, Dressed in Identical Long-Sleeved Dresses, carte de visite,* ca. 1870, private collection

Emily Brontë. But it would be more accurate to consider the marvel of the phenomenon as its explanation. Each sister was the other's most constructive critic, challenging audience, and loyal supporter. In the case of many women, like the Brontës, there was for many years no other. Morisot grew up in an atmosphere infinitely freer and more stimulating than the Brontës': privileged, teeming with new ideas, opportunities, and companions. But in her crucial, formative years, she too depended most of all on her sister. Behind Berthe Morisot was Edma Morisot.[69]

When Lottie Hurley photographed two sisters, she conveyed their dynamics visually by posing them so close together their forms overlapped but distinguishing them by arm gestures and head tilts (fig. III-D-2).

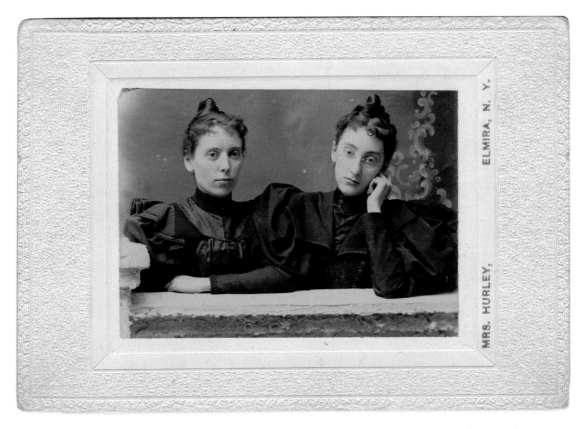

III-D-2 Lottie C. (Mrs. S. L.) Hurley, Elmira, New York, *Two Sisters, Leaning against a Parapet*, cabinet card, ca. 1890s, private collection

The significance of this familial bond is reinforced by the fact that many sisters headed to the photographic studio together to have a joint portrait made. As we survey these many images of sisters taken by camera operators across the country, we rarely have the names of the sitters. So in the absence of even basic identification, how do we unravel these female-female relations? Visual evidence can assist us. As selected *cartes de visite* indicate, even when the women wear the same dress and hairdo, there are slight deviations in their appearance that distinguish their identities. In Mr. and Mrs. Field's portrait, one wears a cross around her neck while the other sports a bar pin (fig. III-D-3), while in Annable's portrait the young girls, while identically attired, wear their short hair in slightly different styles (fig. III-D-4).

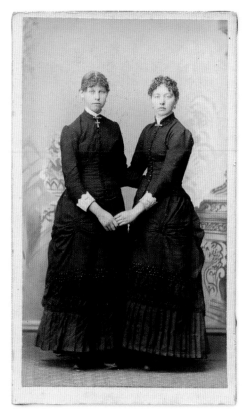

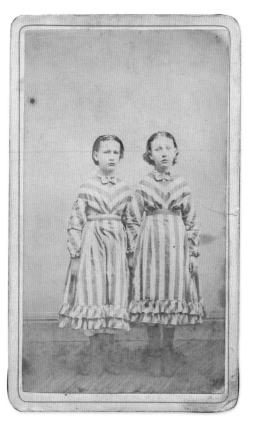

III-D-3 William and Margaret J. McGinley Fields, Lyons, Iowa, *Two Standing Young Women in Identical Dress Holding Hands*, cabinet card, ca. 1885, private collection

III-D-4 Annable's Photographic Studio, Leland, Illinois, *Two Young Girls in Identical Striped Dresses*, *carte de visite*, n.d., private collection

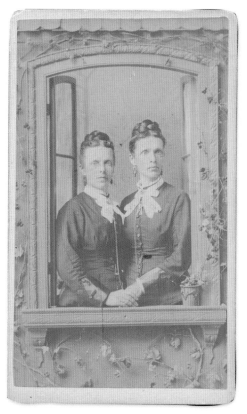 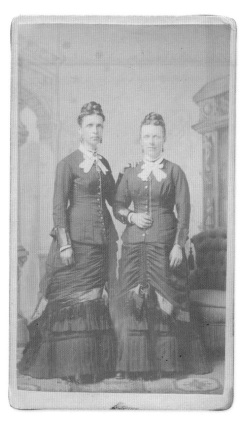

III-D-5 Mrs. J. Wolf, Brooklyn, New York, *Two Sisters Dressed, Coiffed and Accessorized Identically, Holding Hands in a Window Frame, carte de visite* (1/2 matching cdvs), n.d., private collection

III-D-6 Mrs. J. Wolf, Brooklyn, New York, *Two Sisters Dressed, Coiffed and Accessorized Identically, Standing Arm in Arm among Studio Props, carte de visite* (2/2 matching cdvs), n.d., private collection

A charming and scarce pair of matching studio cdvs depict two sisters dressed, coiffed, and accessorized identically. For the first image they posed in Mrs. J. Wolf's Brooklyn studio, holding hands in a window surrounded by vines (fig. III-D-5), while the second is a full-length portrait of them in elaborate dress (fig. III-D-6).

Some psychological insight can be gleaned from Toni McNaron's observations on the complementary nature of the sister-sister bond, which offers closeness on a psychic level, and a desire for intimacy. Yet, despite this, adult sisters often repeat behavior patterns ingrained from childhood:

> Either one sister encourages the other to play out some complementary self that she does not or cannot become, or forces around them are such that complementarity becomes the pattern within which both act out their adult lives. It is as though unconsciously the pairs . . . evolve a system in which they develop only certain parts of themselves in order to cut down or avoid altogether the powerful pulls toward competition found within virtually any family.[70]

Nineteenth-century women authors, including Mary Wilkins Freeman, offered perceptive analysis of the female psyche. Her New England short stories emphasized that one of the strongest, most intimate, and most tenacious bonds is that between adult sisters.[71] Scholar Carroll Smith-Rosenberg picked up on this idea and noted the extreme centrality of close-kin relationships, especially sister relationships, in women's lives during the nineteenth century. Unlike most other female-female relationships, as she concludes, "sisterly bonds continued across a lifetime."[72] These photographs, in which one sister is the visual echo of the other, document these compelling relationships. They confirm that these pairs were like the old vaudeville teams, who worked best when they worked together, united in spirit and possessed of complementary talent but determined to assert their individual identities.

The Family Album

Turning the pages of an album, the viewer gained insight into the compiler who had both selected the individuals to be included and arranged them in a certain order within its pages (fig. III-E-1). This compilation of portrait photographs transformed the album into an encyclopedic record of the family's history. To augment portraits of household members, photographic emporia peddled images of political leaders, celebrities such as musical performers or actors, and other public figures for sale. These images, too, would make their way into the albums, scattered among pictures of children, parents, and grandparents. President Abraham Lincoln and African American activist Frederick Douglass were two of the most frequently photographed men of the era, but there was a wide range of celebrity photography from which to chose in the 1860s and 1870s.

The first photographic albums were created to hold *cartes de visite*. They often provided the focal point for gatherings of family members and their guests, who perused them together, as the photographs mediated between host and visitors during these social engagements. Along with the stereoscope viewer, they offered a form of entertainment—a collective activity to stimulate conversation and perhaps even a bit of merriment as the group reminisced over humorous incidents related to individuals portrayed. The album bridged the domestic world of the family and the public outside world. In both organization and usage, it provided a repository of family memories and a record of its relations to one another and to the broader community, all to be shared among friends in the comfort of the parlor.

Dutiful Daughter: Lucretia A. Gillett of Saline, Michigan

A rare surviving self-portrait by a female photographer allows us to look into the face of Lucretia A. Gillett (ca. 1820–ca. 1894), who is seated in the same woven-back chair in which she captured so many of her clients, including an unidentified grandmother and baby (fig. III-F-1). With slightly slumped shoulders and crossed arms, she appears tired from what must have been a busy day in the studio, to judge from her extensive output. She looks off into the distance and avoids our gaze, lost in thought.

Lucretia was born in Cayuga County, New York, probably in the summer of 1820. Never married, she remained with her parents as long as they lived, moving with them to north-central Illinois around 1850. Eight

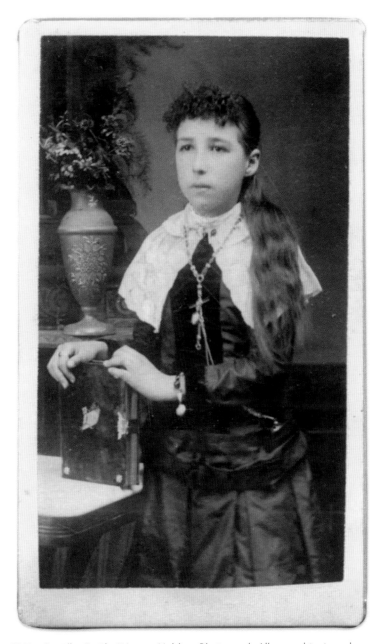

III-E-1 Costillia Smith, *Woman Holding Photograph Album*, cabinet card, ca. 1880–89, private collection

years later they were in Saline, Michigan, where by 1860 she began her nearly thirty-year career as the town's only commercial photographer. Initially she learned to make daguerreotypes from her brother George and transitioned to the newer wet-plate process when it became available, making cheaper, reproducible albumen prints. Her primary focus was the studio portrait—printed first on *carte de visite* and later cabinet cards—but she was known to make architectural studies and even Christmas cards. Her younger sister Ann did the printing on the paper mounts, including the monogram of the National Photographic Association that appears on the verso of the studio's photographs for some years. Records indicate that Lucretia donated small sums to the National Photographic Association, as well as to Photographic Hall at the Philadelphia Centennial.[73] These gestures indicate a desire for connection to national photographic networks that was difficult to fulfill, given her responsibilities to her family and local clients.

Eager to pass on her hard-won technical skills, she also mentored younger colleagues. Following the death of her father in 1875, she opened up the family home as a boardinghouse. Among the residents was Laura A. Green, who doubled as a household servant and photographic assistant. By 1889, having learned the secrets of the trade from Lucretia, Green opened her own photographic studio in the nearby town of Manchester. The well-known photographer of western scenery F. Jay Haynes was also said to have apprenticed with her.[74] By 1890 she sold her business to George Waterman, who advertised his new business as "Miss Gillett's old stand." She then departed for Long Beach, California, to live with her sisters Ann Gillett and Delia Shepherd.[75] While she left behind a substantial body of portraits of local Michigan residents, her hope of broader professional connections seemed to elude her. Perhaps this frustration accounts for her wistful, even melancholic look in her expressive self-portrait (fig. III-F-2).

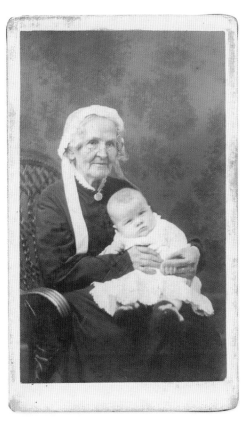

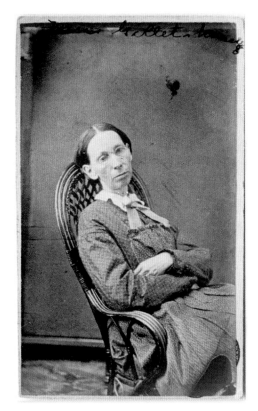

III-F-1 Lucretia A. Gillett, Saline, Michigan, *Grandmother Holding Baby* (identified as Archer C. Davenport), *carte de visite* (with National Photographic Association insignia on verso), ca. 1862–90, private collection

III-F-2 Lucretia A. Gillett, Saline, Michigan, *Self-Portrait, carte de visite,* ca. 1862–90, Clements Library, University of Michigan

Folsom's Danbury, Conn.

Mrs. J. H. Folsom's Studio

National Bank Building

next door to library.

Danbury, Conn.

Chapter IV
A Visit to a Woman's Portrait Studio
Introduction

Nineteenth-century photographic studios were mysterious places, equal parts creative, technical, and commercial. They housed cameras, backdrops, and props, as well as darkrooms with processing chemicals, parlors that doubled as gallery spaces, and dressing rooms for women and men to prepare for sittings. Shirley Wajda's influential article "The Commercial Photographic Parlor, 1839–1889" presupposes a male photographer and female visitors.[76] Here we aim to unsettle that notion, gendering nineteenth-century photographic studios as feminine spaces.[77] Featuring female photographers, chapter IV pays special attention to subtle nuances that occurred when a woman managed the gallery and operated the camera.

IV-A-1 Recto: *Seated baby*; Verso: *Street-level entrance to Elizabeth (Mrs. J. H.) Folsom's Studio*, Danbury, Connecticut, with her name and display of photographs by the door. Cabinet card, ca. 1880s, private collection.

Few original photographic studios of this era still survive, and none in the United States.[78] Instead, we must rely on a range of visual documents that allow us to piece together the physicality of these environments. A remarkable set of four stereographs from Mrs. G. W. Sittler's gallery in Springfield, Missouri, documents the exterior along with several detailed shots of the interior spaces of the establishment. *Cartes de visite* often feature sitters in a standard "posing chair," with a semicircular back that could be adjusted for height. Periodicals featured views of upscale studios such as Mathew Brady's, with its waiting room that resembled a domestic interior. Mrs. J. H. Folsom of Danbury, Connecticut, illustrated on the verso of her cabinet cards the entrance-way to her studio, complete with a display of her photographs, to guide sitters to her door (fig. IV-A-1). Written accounts and a bit of creativity are necessary to re-create the more intangible, sensorial aspects of the client's visit to a photographic studio.

Once clients found the entrance and climbed the stairs to the top floor of the building—where studios were located to take advantage of skylights—they encountered all kinds of odd sensations. Most striking was the strange intensified light in the room, would have been disorienting for the sitter. Then there were the noxious odors that would have pervaded the space, emanating from the chemicals required for a variety of steps in the process, from the preparation of the plate to the fixing of the image. There were also distracting loud noises from the street, the banter of other customers, and babies crying as they resisted sitting still for the photographer. Eventually they would be summoned into what was ominously called the "operating room," where an employee stood ready to help them pose, which meant relinquishing agency of their photographic representation. The focal point in this room was the camera, mounted on a tripod with four to fourteen lenses staring at the sitter, producing anxiety in an age when people sat for few portraits in a lifetime. Then there would be time to arrange for the final business details by the female head of household who had organized the sittings and now had to pay for them and arrange for pickup.

Now, reimagine that the entire experience is being orchestrated by a woman—operating the technical equipment, mixing solutions, moving your arms and head into position, looking straight at you to frame your portrait, ducking under the dark cloth to shoot your picture, and then convincing you to purchase a few dozen copies of your portrait, including a few to be hand-colored. This section re-creates the experience of thousands of nineteenth-century men, women, and children who submitted to what was then still the novelty of sitting for a female photographer.

Patronizing a Female Photographer: Mrs. G. W. Sittler

Consider the seven gentlemen who appear in the cabinet card taken by Mrs. George W. Sittler (fig. IV-B-1), who worked closely with her husband in the studio they opened in 1882, and ran it on her own after his death in 1887. Under her "sagacious management," it was reported in 1889, she "maintains its front rank in advanced photography of the Southwest" and stamped her work with the motto "Sittler's photographs are the best."[79] In order to have their portrait taken, this group would have perhaps made an appointment or, more likely, just dropped

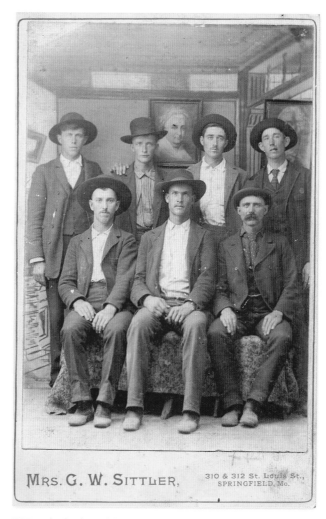

IV-B-1 Elizabeth Middlesworth (Mrs. George W.) Sittler, *Group of Men*, cabinet card, ca. 1888, private collection

in at the gallery located at 310 and 312 St. Louis Street in Springfield, Missouri. A series of four stereographs that the Sittlers shot of their own establishment provide a rare surviving glimpse of a studio interior and its many interrelated departments that kept these commercial establishments running successfully. We can follow the physical path of these seven male sitters as they negotiated the spaces of this commercial studio, which featured not only a female photographer, but also a female staff who fulfilled its many other tasks.

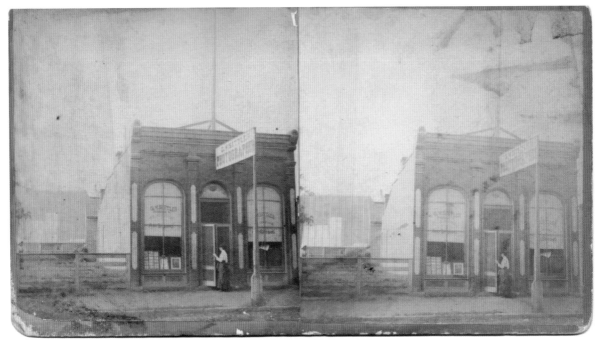

IV-B-2 Sittler, exterior of Sittler Gallery, stereograph, ca. 1880, private collection

From street level the men would have had easy access to the studio, identified by lettering on the plate glass window and a prominent sign suspended high above the sidewalk between the building facade and a lamppost, as documented in the first stereograph. Unlike the big-city studio, which required the client to climb multiple flights of stairs to reach the top floor with its requisite skylight, the Sittlers had the small-city advantage of a single-story building with direct entry. A woman dressed in a dark skirt and a white blouse—likely Mrs. Sittler—stands by the door and appears to be leading the potential clients inside (fig. IV-B-2). An assortment of stereoviews and prints are displayed in the window, a common practice to advertise sample work.

The clients then proceeded into the anteroom of the gallery, with more images hung for viewing and display cases filled with ready-to-use glass plate negatives, cameras, and lenses.[80] These were from the stock department that, as the press reported, "is replete in everything necessary to the production of first-rate work." The Sittlers were clearly enterprising, trading not only in their own pictures but also in supplies, for which there was an increasingly ready market in the 1880s as the techniques became more simplified and more amateurs tried their hand with the camera. Next came the parlor, which contained an office desk where the photographers kept their records and arranged payments. "The reception room is elegantly fitted up with portraits of all sizes, in ink, oil, crayon and photography; photos as large as 20 × 34" taken direct from the sitter" (fig. IV-B-3).

In other areas of the building, women worked behind the scenes, as we read in the *St. Louis Photographer* in 1885: "To the right, as you enter the reception room, is the retouching room, presided over by Miss Mattock,

who wields the pencil on the negative with as much dexterity as she would were she indicting a love missive under the inspiration of cupid. The printing department is still further back, and here Miss Middlesworth holds full and complete sway. Everything is handy and in order, and by the appearance of her prints, she is no novice in her department."

Finally the sitters arrived in the sanctum sanctorum—what was called the "Operating Room" (fig. IV-B-4). It was much brighter than the other rooms through which they had passed, thanks to an adjustable natural light source at one side (likely coming in from the big plate glass panels along one side of studio annex visible from the exterior). Standing about the room were not only the cameras and stands, but also a full backdrop to emulate a Victorian parlor complete with shelves and bric-a-brac. There were several props, including a swing hanging from the ceiling, available for young women and children to sit upon. Here, as a journalist reported, Mrs. Sittler "takes charge of the operating room and renders all the fine poses," and pointed out that she "should come in for the lions share" of the "credit for this fine and prosperous establishment." Not only did the Sittlers provide rare visual documentation of their interiors, but written commentary emphasized female contributions to their success: Miss Mattock in retouching and Miss Middlesworth in printing, as well as Mrs. Sittler's part in posing the sitters. This evidence confirms that the Sittler gallery—like many of its counterparts—functioned as a gyno-social environment.

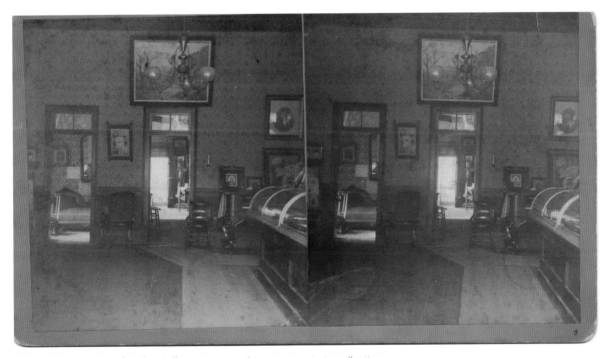

IV-B-3 Sittler, interior of Sittler Gallery, stereograph, ca. 1880, private collection

IV-B-4 Sittler, operating room of Sittler Gallery, stereograph, ca. 1880, private collection

It is likely that Mr. McNulty and his six comrades consulted with Mrs. Sittler about the setting for their portrait. In the end, they were clustered in an interior: three men sat on a divan while four stood behind them, all wearing their brimmed hats. A space between the two central men in the back row reveals a bust-length portrait of a white-haired woman hanging on the wall behind, while on the right side, half hidden from view, hangs its pendant, with only a high forehead and white-haired wig visible. They likely represent Martha and George Washington, a patriotic reference gone slightly awry with the misalignment of the sitters.

There were half a dozen photographic galleries in Springfield, Missouri, but G. W. Sittler was "a general favorite in the city," due in no small part to his "artistic tastes and attainments and rare social and business qualities," a journalist reported. But upon his passing, Mrs. Sittler "has extended her trade in photographic supplies well over this and neighboring states." The journalist continued:

> She also manufactures Sittler's improved chemicals for photographing on silk, satin, linen and other fabrics, and has a large and rapidly growing photographic business; employs a good force of skilled operators in oil, crayon, pastel and India ink work, besides artistic photography from the minutest forms of portraiture to life size pictures direct from the sitting.

With one eye on the artistic side of things and the other on the business angle, Mrs. Sittler and her sister-hood navigated their studios to success late into the nineteenth century.

Say Cheese! How to Sit for Your Photograph

IV-C-1 Martha Fletcher, Massillon, Ohio, *Young Child in a Posing Chair*, carte de visite, ca. 1859–70, private collection

A good deal of anxiety surrounded the experience of sitting for a photograph in the early days of the medium. As late as 1897, the Washington, DC–based photographer Frances Benjamin Johnston noted that "most people consider dentistry and having their picture taken as being equally unpleasant and painful, and shrink from the one quite as much as they do from the other." She tried to brush such fears aside as entirely unfounded: "I do not know if dentistry can be robbed of its terrors, but I am sure that the imaginary suffering of those who visit the photographer can be to a great extent mitigated." For Johnston, these negative connotations lay with the setting and "can be wholly dispelled by making the studio of the photographic artist inviting and attractive."[81] For others, however, their concerns ran deeper than just the physical surroundings. Questions arose about which photographic studio to patronize, the cost of the pictures, and, of course, what to wear and how to pose. Usually it was the woman of the house who made the decision to have family photographs made. First she pondered the choice of photographer. If there were a female operator in the city or town, then perhaps she would have engaged her, since the accepted wisdom was that women were more adept at getting the

children to cooperate. But just to be sure, she might visit a few different establishments to see samples of their work and compare prices. Then on the appointed day, she lays out the best Sunday clothing for herself and her family, arranges hair, and straightens ties. In the selection of wardrobe and other details, she could have found advice in the manual *How to Sit for Your Photograph* (1872).[82] "It gives, in an amusing way, interspersed with many good points and lots of genuine fun, just such information as the all and ever important subject of sitting for a picture as the public wants," one reviewer noted. Written by "the wife of a well-known photographer," it provided practical advice intended to alleviate every apprehension associated with having one's likeness fixed on the photographic plate. Many photographers had copies of the book on hand in their studios, so that patrons who did not want to purchase their own copies could consult it on-site.[83]

After getting dressed at home, the group proceeded to the studio, and if there was a "ladies only" entrance, mother would guide her children toward it so that they could slip into a private room—free of prying male eyes—to make a few last-minute adjustments. Until it was their turn before the camera, they could explore the waiting room, looking at sample photographs and other artworks on the walls. Then came the big moment when, one by one, she and her children would take a turn in the posing chair to be recorded for posterity (fig. IV-C-1). In the very early days of the medium, exposure times were long and photographers employed metal clamps to hold the subject's head in place, to avoid any motion that would blur the final image. But as exposure time shortened, this was no longer necessary, and the camera operator aimed for a more natural likeness. Some photographers would manually move the sitter into place, turning heads or bodies this way or that. But as more-skillful operators knew, people were unaccustomed to being manhandled in this way and preferred more gentle treatment. "Do not attempt to pose people, or to strain our sitters into uncomfortable or awkward position, in order to obtain picturesque effects," Johnston advised. "Watch them, and help them into poses that are natural and graceful. Study their individuality striving to keep the likeness, and yet endeavoring to show them at their best."[84] Many female photographers became adept at putting their clients at ease, quickly sizing up their best features and then taking their shot with some dispatch.

A few days after the sitting, the woman of the house would return to pick up the mounted *cartes de visite*. Once she inspected the small albumen prints, she might decide to have a small selection of them hand-colored, which added a bit to the price but made the sitters appear more lifelike, with a slight blush on the cheeks and a dash of color to enhance a dress or bit of jewelry. The individual photographs were then mounted on cards and stamped with the studio logo, while the negative was kept on file in case more prints were required in the future. Finally, the client paid the photographer's fee out of money saved from the household expense account, and returned home with the pictures. Later she would insert the photos in an album kept in the parlor, where it would be shared during visits with family and friends.

For Best Effect: Dress, Hairdos & Hats

The women pictured in these *cartes de visite* apparently failed to consult one of the many guidebooks available on how to dress for their photographs. Miss Royce's client decided to wear a dress of prominent vertical stripes, a style that was definitely not recommended (fig. IV-D-1). Since this was a dual photograph of mother and child, however, the contrast of the mother's stripes and the child's garment of a solid color works in this case. In Geneva, Ohio, Miss R. M. Thorp photographed Eliza Chapman Potter (whose name is penciled on the back) around 1864 (fig. IV-D-2). That date, indicated by the presence of the revenue stamp affixed to the reverse side of the cdv, tells us that this was done during the Civil War, likely to create a keepsake to give to Potter's sweetheart or husband as he headed off to the battlefields. She cuts a striking figure in her plain dark jacket and full, polka-dotted skirt, even though, according to the experts, such patterning was to be avoided. So much for advice!

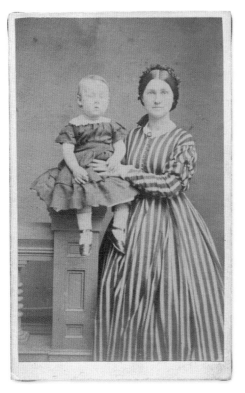

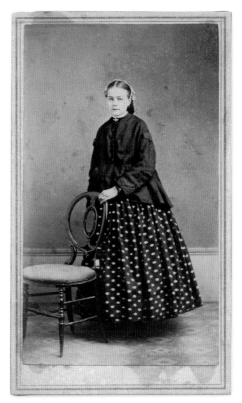

IV-D-1 Roana Royce, Willimantic, Connecticut, *Mother & Child, carte de visite*, ca. 1865–75, private collection

IV-D-2 Ruby M. Thorp, Geneva, Ohio, *Woman in Polka-Dotted Skirt* (Identified in pencil as "Eliza Chapman Potter"), *carte de visite* (with revenue stamp on verso), 1864-66, private collection

For directions on the best clothing to be worn and the reasons why some fashions photographed better than others, see the following article, titled "The Effect of Dress in Photography," excerpted from *Gay's Illustrated Circle of Knowledge*, by William Gay (New York: Gay Brothers, 1886):

For Ladies: The Style and Color of Dress

"You will learn how to dress for the best effect by carefully studying [this advice]":

There is nothing which tries the patience of the artist and displays the want of judgment and good taste in the subject more than the matter of dress and combination of colours. Remember that fashion is a fickle goddess, and in a photograph which is to last for years it is best to have the dress such as will produce the highest artistic effect. It often happens that a person becomes wary of a particular style of dress in a picture when the face is perfectly satisfactory.

The persons in the theatrical profession take the best photographs because they understand the art of producing effect, and often come to the studio with the materials for making up the best appearance, and permit the artist to select and arrange them so as to hide a defect here, and increase the effect there. Ladies should be careful to dress in those materials that naturally fall in neat folds, or drape neatly about the person, such as poplins, silks, satins, or reps. They should avoid that which has too much gloss, as this reflects the light, but often the operator can overcome this by a proper disposition of the light. Dark orange, golden and red brown, dark green, bottle green, sherry or wine colour will take dark but not black. Light orange, sea green, leather colour, slate, light, Bismarck, scarlet garnet and claret are all good colours for a photograph. Pea green, pink, crimson, magenta, dark purple, pure yellow, blue, navy blue, fawn colour, dove, ashes of roses, buff, plumb and stone colour, will appear a pretty light grey which photographed. The worst colours to take are sky blue, French blue, blue purple, lavender and lilac, even more objectionable than pure white. Salmon and corn colour are preferable to these. Dark Bismarck and snuff brown will take darker than black silk. Silk goods will usually produce a lighter shade than woolens of the same colours. Always avoid striped goods, or those of a bold design, as they will ruin the picture. Do not wear anything that will take streaked or spotted. Fine shadow pictures are produced with white drapery in deep folds, having the bodies trimmed with laces and puffs. . . . A large patch of white on a dark dress in a picture destroys its beauty, therefore do not wear blue, or pink ribbons, nor trimmings. The converse is also true.

For Gentlemen

The advice given above is also applicable to gentlemen as far as they apply. A plain business suit of good colour and material will always take good with white linen and plain watch chain across the vest.[85]

Painted portraits dictated propriety in pose, clothing, and hairstyle. Formal portrait photography often followed suit, but sometimes in the less expensive formats—especially the tintype and *carte de visite*—people could be more playful, experimental, and downright comical. When a woman visited a photographer's studio, she might let down her hair or try out different arrangements of her hair—maybe across the face or behind the ears—and she might even add a hat or bow. Especially with tintypes, a woman could play with curls and combs to try out a variety of different looks, knowing that she could have more images taken relatively cheaply. Some female photographers advertised their skills as hairdressers, ensuring clients assistance in arranging their coiffeurs. Besides the arrangement of the hair, consideration had to be given to its shade and the most appropriate color for clothing to complement it. Books and pamphlets detailing how to prepare for your photograph devoted substantial coverage to "the effect of the hair," including the following advice offered in 1886:

> Persons who have light hair should select lighter clothing than those who have darker hair, and for this reason light shades take more quickly than dark; therefore if a person of light complexion dresses in dark colours the face of the dress will be "over done." The converse holds true of persons who have dark hair, they should avoid too light clothing.

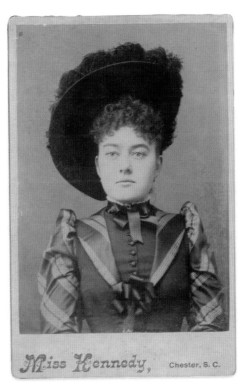

IV-D-3 Sallie Kennedy, Chester, South Carolina, *Woman in a Broad-Brimmed Hat*, cabinet card, ca. 1885–90, private collection

No respectable nineteenth-century woman was considered fully dressed until she donned her hat. A number of women, therefore, decided to pose for their photographs hats and all. Sometimes the hat was ill fitting, suggesting that perhaps the photographer had it on hand as a studio prop that was selected at the last minute without regard to its suitability to the client. Most of the time, however, the photographer posed the sitter in such a way that the hat framed her face well, enhancing the overall look of the portrait. The broad, dark brim of the hat that frames the young woman who sat for Miss Sallie Kennedy (active 1889–1906) in Chester, South Carolina, ca. 1890 provides a dramatic frame for the face and helps balance the top half of the image with that of the bottom (fig. IV-D-3).[86] Other female sitters wear hats with protruding feathers and flowers, adding a more lighthearted, jaunty touch. Men, too, found that the right headwear could make them look more distinguished, and topped off their attire with a distinctive cap or hat.

Retouchers

An initial glance at an ambrotype or *carte de visite* portrait with hand-coloring applied draws our attention to the sitter and how lifelike she or he appears. But look again, and now think about the individual, usually a young woman, who applied the color to the surface of these small objects, and ponder not only the skill but also the stamina it took to sit at a table day after day performing this close and careful work. Usually this work was accomplished by a woman who had some art training and perhaps aspired to be a fine artist, but settled—at least temporarily—for this more routine and anonymous task. Those lacking formal training could consult a growing number of how-to manuals. George B. Ayres's *How to Paint Photographs in Water Colors and in Oil [Coloring]: How to Work in Crayon, Make the Chromo-photograph, Retouch Negatives and Instructions in Ceramic Painting* first appeared in 1869 and went through numerous subsequent editions, testifying to its popularity.[87] So who were these women—called "retouchers" or sometimes "coloring artists" or "photo colorists"—who earned a living coloring photographs, and what specifically was the nature of their work? One photographer turned the camera on the retoucher (fig. IV-E-1), whom we see applying watercolor to the photograph on her workstand while the smaller cdv sits in the rack, ready to be colored next.

To meet the rising demand for photographs, women were employed in a variety of capacities: greeting the customers in the gallery, preparing sitters for the camera, cracking eggs and mixing albumen for prints, affixing the photograph to the card backing, and retouching portraits—tasks requiring attention to detail, for which women were considered especially well suited. Since photography was an emerging industry not yet regulated by labor laws, women could be hired cheaply with few rights: an added incentive for some employers. "To-day hundreds of young women are devoting themselves to [retouching]. The technique of the work is simple," Frances Willard explained. "Many women earn from twelve to fifteen dollars a week by executing orders. After a short course of study they are able to earn more. A knowledge of drawing is necessary . . . there must be a knowledge of color."[88] From the beginning, photographers often hand-tinted or overpainted their handiwork to compensate for the medium's inability to reproduce natural color. The skills of a coloring artist or retoucher were especially necessary to portrait photographers, whose challenge it was to make flattering likenesses of

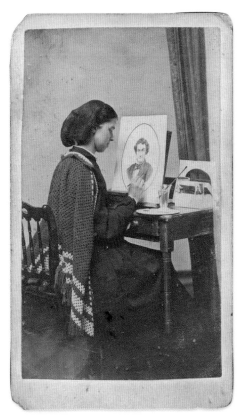

IV-E-1 Photographer unidentified, *Young Woman Retouching Photographs, carte de visite,* n.d., private collection

their sitters. A subtle hint of pink to a cheek provided a spark of youth and vitality to a stiffly posed figure. Embellishing the clothing or occasionally jewelry with a flick of paint gave it prominence, signaling the sitter's social standing and respectability.

As time went on, hand coloring became a common practice for albumen prints. Women placed notices in the "Situation Wanted" column of trade journals such as the *Philadelphia Photographer* and elsewhere, advertising their availability for a variety of positions, including that of a retoucher.[89] Their numbers grew to the point that they presented an economic threat to their male counterparts, some of whom attempted to condemn them as "lady amateurs" doing inferior work. Some women were able to use these positions to their advantage, as a stepping-stone to more-advanced opportunities in the field. Portraiture constituted a significant portion of the colorist's work, but sometimes tints were applied to landscapes or genre scenes, as in the case of a fireside scene where the flames were enlivened with a vibrant red (fig. IV-E-2).[90]

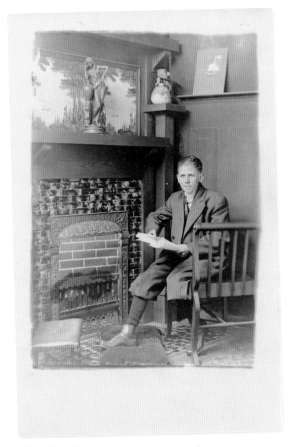

IV-E-2 Mrs. Philleo Studio, Rock Island, Illinois, *Young Man by a Fireplace*, postcard (with hand coloring), n.d., private collection

Some photographic colorists labored under conditions not unlike nineteenth-century sweatshops or factories: hours were long, lighting conditions were poor, and the rooms were roasting hot in summer and freezing in winter. There were recorded complaints of cramped quarters, with six or seven people working in a small space often illuminated via a skylight. They were under the watchful eye of a supervisor, who allowed little time for either their eyes or hands to rest from this closely rendered, detailed work. But hand coloring could also be done as piecework that women could fulfill at home. Many set up a small area in their domestic space so that they could conduct their labors by gaslight once the children had gone to bed.

The nineteenth-century photographer aimed to heighten the likeness of the individual, with little concern for the idea that the photograph had to remain pure, as the formalist aesthetic of the twentieth century would dictate. Rather than concealing the touching up or manipulating of photographs, it was very much out in the open in the nineteenth century, and the coloring artists were occasionally acknowledged. "F. Coombs, Daguerrean, at Wells & Co.s new building, corner of Clay and Montgomery streets, has the pleasure to

announce that he has secured an additional coloring Artist," it was reported in the *San Francisco Herald* in 1850, "a young lady who has presided over the finishing department of the first Gallery of Boston for several years. He hopes in the future to accommodate every applicant with a Picture which will bear comparison with the choicest."[91] Not infrequently, male photographers employed their wives as retouchers. One early example is Boston's famous daguerrean duo Southworth and Hawes, where Nancy Southworth Hawes (the wife of Josiah Johnson Hawes and sister of Albert Sands Southworth) was responsible for hand-coloring the daguerreotypes as well as the day-to-day operations of their establishment (1843–1863). In San Francisco, Sarah Dutcher worked as retoucher for Carleton Watkins and apparently provoked the jealousy of Mrs. Watkins. Called the "tall lady," she was the first woman known to have climbed Yosemite's Half Dome.[92] In rare instances the retoucher was even identified, along with the photographer on the mount. A bust-length cabinet card portrait of a woman was stamped on the verso: "H. Osterhout 6 East Main Street, Middletown, N. Y. F. E. Weeks, Retoucher."

Although intended as fiction, the following account from 1889 provides insights into the female retoucher's life:

> Ivy Dawson is a retoucher in a big photographic gallery. New York is full of girls just like her, and I dare say you have often seen her curly black hair over the nape of her slender white throat, if you have not caught a glimpse of her rosy face and smiling lips. She sits in the strong light of _____ Studio window, her head bent over her easel, a magnifying glass in her eye, a pointed pencil in her hand, busy from dawn to dark taking out wrinkles and putting in dimples. She needs no retouching herself, poor dear, but in spite of her shabby dress looks as bright as a blue print of fresh ferro-prussiate paper, and is to all appearances as contented a breadwinner as can be found in the whole city.[93]

Supporting the camera operator, countless women worked behind the scenes, and although—unlike Ivy Dawson—they remain largely unidentified, their contribution to photography is undisputed.

Public-Relations Wizard: Rosa Vreeland-Whitlock

Rosa Vreeland-Whitlock (1852–1925) negotiated an impressively long career, running a studio for thirty years, from 1881 until about 1911. Primarily based in McPherson, Kansas—about 60 miles north and slightly west of Wichita—she had, at various times, other satellite photographic establishments in the region. She was active in photographers' associations, but she focused primarily on managing her studios along with a turbulent personal life, which spanned three marriages. In 1881, when she began photographic work, she was a married woman and mother of two children. Her husband, Cornelius Vreeland, started out as a farmer and then joined her as a photographer, but by the end of 1884 she and Cornelius were no longer together. In 1890 she married Ogden Whitlock and rebranded her gallery as Mrs. Vreeland-Whitlock, but in 1894 she was suing Whitlock for divorce. Around 1900, she married for the final time, to a dentist named Dr. J. C. Herron. Like her first husband, her son George followed her lead and became a photographer.

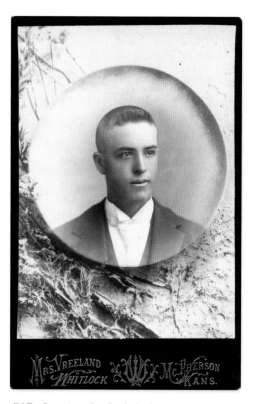

IV-F-1 Rosa Vreeland-Whitlock, *Young Man in a Tuxedo*, cabinet card (with memorial border), 1885–1900, private collection

What distinguishes Mrs. Vreeland-Whitlock, and probably accounts for the longevity of her gallery, is her unflagging entrepreneurial spirit, reflected in the advertisements she regularly placed in local newspapers. There are literally hundreds of them, a sample of which demonstrates how she charted her public-relations gambits, which started out small and expanded over time (fig. IV-F-1). Of the mounds of press notices touting the services of female photographers all over the country, hers are in a class by themselves. They stand out because she continued to evolve as a photographer, rethinking the requirements of her medium, and wasn't shy about letting her potential clientele know that she had what it took to make a good picture. She was also increasingly creative, not only in the content but also in the form of her self-promotional strategies, including experiments with graphic design. And finally, and perhaps most importantly, she understood human nature and what it took to lure someone into her studio to sit for a portrait.

That psychological insight is evident in one of her advertising campaigns in the 1880s. Playing on people's tendency to postpone tasks, she warned local readers that they would regret waiting too long to have portraits made:

PRO-CRAS-TI-NA-TI-ON

Is dangerous. June 1, expect to close my gallery for vacation, so do not postpone having your pictures taken until "to late" [*sic*]. I shall have a view outfit for making large views this fall. All desiring such work done will do well to give me a call. Respectfully, Mrs. Rosa Vreeland.[94]

She also instructed locals in the technical elements essential to a good photographic portrait and emphasized her mastery of them:

Of paramount importance is expression. The man or woman whose expression is natural and hence correct and gracious is eminently rich in the possession of dignity and excellence of character. Expression is the key to character. Think of this then have Mrs. Vreeland Whitlock take your picture.[95]

Most photographers noted that they made copies after old pictures, but here again Rosa Vreeland-Whitlock did it more creatively, deploying sentimental poetry:

Mother's Picture

I bring you the picture of mother dear

Taken so long ago,

It is scratched and faded, as you see

But it is all I have you know.

Take out the wrinkles in the dress,

And add a collar, please:

Leave the dear hands as they are,

They look so much at ease.

The expression, I would not have changed

Nor the hair, so streaked with gray

But make the eyes as good as you can

For they were bright as day.

Above is the prayer that mother-loving ones make to Mrs. Vreeland Whitlock, who copies old pictures and restores them by a new and lasting process. Studio corner Ash and Elizabeth streets.[96]

In the late 1890s she was still going strong, with her advertising taking new angles. Capitalizing on the feelings of inferiority that residents of provincial towns and cities always harbor, Mrs. Vreeland assuaged their fears:

> It is too often the case that people of a city of the smaller size are compelled to patronize an inferior artist or go abroad for photographs. This is not the case in McPherson, where Mrs. Vreeland has established her Art Studio, where not only meritorious work is done, but where photographs are made that the best galleries in Kansas City would be pleased to mark with their trade mark.[97]

She understood "posing, something that many photographers are deficient in, and thus brings out all best features without destroying the likeness." Retouching could be tricky, but here too "she adheres strictly to the rule that prevents destruction of likeness for the sake of fine effect, and thus makes perfect work with perfect likeness." And in portraits of children, "Mrs. Vreeland is more than ordinarily successful, her child pictures being recognized as the best by all photographic artists."[98] She even advertised a special device for capturing good baby pictures: "Try the patent 'baby holder' at Mrs. Vreeland's gallery. Latest invention for taking baby pictures."[99]

Over three decades this enterprising woman mastered a succession of technological and optical advances. When she closed her studio doors for good in about 1911, her enormous body of work testified to her declaration that "Mrs. Vreeland Whitlock rejoices and is exceeding glad that she has lived to see this day."[100]

"Dredful Picture," or the Portrait That Goes Wrong

There must have been many times when a sitter was not happy with a photograph, but those reactions go unrecorded for the most part. Occasionally, hints emerge of the feelings people had upon seeing themselves recorded for all time in a portrait print. Take the example of a cabinet card of a mature man and woman holding a parasol by one Miss Mary Duquette of Merrill, Wisconsin. It provides a rare expression of dissatisfaction, for recorded on the back in blue pencil is the phrase "Dredful [*sic*] picture" (fig. IV-G-1). The woman in the photograph looks so happy, as if she is on an outing and having a ball. The man, who wears an ill-fitting hat resting on his ears, looks a bit more dubious and was likely the author of the commentary.

Sometimes it was the hand coloring that marred the image, as in the case of a portrait of a brother and sister, identified as Lizzie and Ernest Hubbard on the verso in pencil (fig. IV-G-2). Working in Lockport, New York, Mr. and Mrs. Graves made a respectable likeness of the young duo. But when the image got to the hand colorist, things went a bit awry, and red hand coloring took over the image.

We have all had the experience of confronting a visual record of ourselves that fails to jive with our self-ideal. The scribbled remarks of Miss Duquette's client speak volumes across time and place.

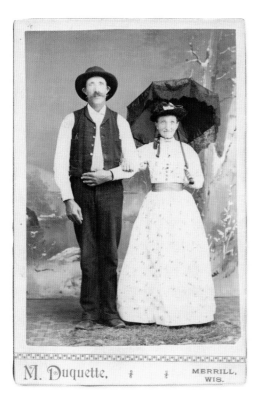

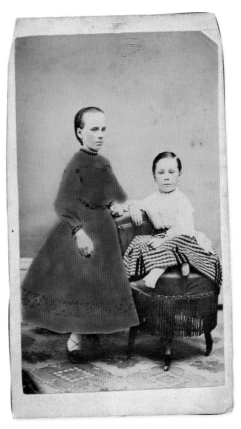

IV-G-1 M. Duquette, Merrill, Wisconsin, *Man and Woman with Parasol* (in pencil on verso: "Dredful picture"), cabinet card, ca. 1885–90, private collection

IV-G-2 Mary Sophia Campbell Graves and Edward Rufus Graves (Mr. and Mrs. Graves), Lockport, New York, *Brother and Sister* (handwritten in pencil on verso: "Lizzie Hubbard, Ernest Hubbard"), *carte de visite* with hand coloring, ca. 1864–70, private collection

CHAPTER V
OUTDOORS: LANDSCAPE & ARCHITECTURE
Introduction

If Eliza Withington wanted to work in the open air in the early 1870s, then she had no choice but to use the cumbersome wet-plate collodion technique, including the preparation of the glass plate negative on the spot, which required a darkroom along with chemicals and plenty of fresh water. But change was on the horizon after 1871, when Dr. Richard L. Maddox invented dry-plate photography. By 1879 it was becoming firmly established, since the once-complex chemistry was now handled in the factory, and prepared plates utilizing gelatin emulsion were being sold. Gelatin offered many advantages over the old collodion foundation, most importantly indefinite storage and improved light sensitivity—as much as sixty times greater. This process provided the camera operator with new freedom, since the preparation time shortened and the possibility for mobility expanded. Thereafter, women and men alike could operate with greater ease.

Photographic supply companies wasted no time in appealing to women: "Photographic Outfits, Every description of First-Class apparatus. Outfits from $8 upward," L. M. Prince & Bros. offered (fig. V-IN-1). "Send for our catalogue of supplies which gives full information regarding this *new method of photography* [emphasis in original]. The ad, which featured a well-dressed woman photographer operating her streamlined camera perched on a tripod, continued: "Anybody can make good photographs with the Dry Plate outfits. No previous knowledge of the art necessary." Interestingly, however, the target audience was still the professional: "Business sustainable for everybody. $50 to $75 per week easily made. Process simple and sure. Catalogue of 180 pages with complete instructions of *How to Make Pictures* sent on receipt of 20 cents for postage."[101] Mary Jacobson in Texas, Sarah Short Addis on the California-Mexican border, and Nebraska's Mary Jane Wyatt, discussed here, all availed themselves of these technical improvements.

Landscaping in California: Eliza Withington

In 1850 California became the thirty-first state in the US, and two years later Eliza Withington arrived there with her two daughters in tow to reunite with her husband, George, one of the Forty-Niners who had been lured there by the gold rush. By 1857 they put down roots in nascent Ione City, located in the Sierra Nevada of east-central California, with Sacramento—the nearest large settlement—located 50 miles northwest. While most of the small hamlets in the area owed their existence to gold mining, Ione had the added advantage of being an agriculture and supply center and transportation hub (first the stagecoach, and, after 1876, the railroad). But by any standards it was a frontier town, with few amenities and a population made up largely of rough-and-tumble people seeking their fortunes in the West. It was not the most obvious place for a woman to open a photography gallery, but that is exactly what the intrepid Eliza Withington did in July 1857.

She adopted "Excelsior" as her personal motto and claimed to have "recently visited not only [Mathew] Brady's celebrated gallery in New York City but many of the noted galleries in several of the Atlantic States."[102] Tradition has it that she traveled across the country ca. 1856 to tour these establishments and then returned to California. Given the difficulties of cross-country travel at the time, and the fact that Brady's studio had been open in New York City since 1844, it seems more likely that she had visited them earlier, when she still lived in New York before her marriage. Although few details of her training or operations are known, it's also possible that she had contact with photographers on the West Coast, including Charles Leander Weed, who operated a camera in a photography gallery in Sacramento and—like her—soon expanded the business from in-studio portraits to wet-plate landscape photographs. Roughly 120 miles away, San Francisco offered additional options, including its major photographer, Robert H. Vance, who may have also helped the young Carleton Watkins. And she undoubtedly consulted photographic journals and how-to manuals for details of equipment and processing.

Withington rented a studio on Ione's Main Street—"the first door west of the bridge"—where she hoped to attract walk-in clients who wanted their portraits taken. In addition to photography, she also offered lessons in "Oriental Pearl Painting," a decorative art popular among women. A writer for the local newspaper noted that her gallery had "a large and well arranged skylight" and that "she is an accomplished lady and most excellent artist." Confined to capturing the faces and standing figures of local men, women, and children in her studio on a daily basis for more than ten years, she began to chafe at the restrictions of having to please her clients and stay indoors during the hot summers. "Here in the valley, for four months, the temperature is very high, too high for comfort or good photographic work, for several of the midday hours of those months the thermometer coquets with the Centennial number," she wrote in 1876. "When those days come I begin to finish up and dismiss local work." Starting in 1871, she locked her studio door for months at a time and took to the open road to photograph the surrounding scenery. In this last phase of her career, which lasted from 1871 until shortly before her death in 1877 at age fifty-one, she produced her most remarkable work.

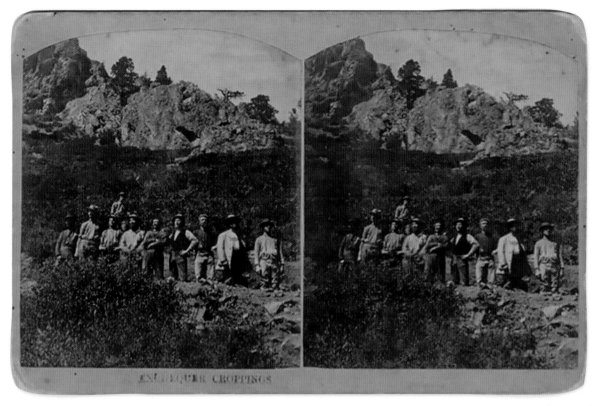

V-A-1 Eliza W. Withington, Ione City, California, *Exchequer Croppings*, stereoview, ca. 1872–76, Peter Palmquist Collection of Women in Photography, Beinecke Library, Yale University

If it was unusual for a woman to maintain her own portrait studio, then it was almost unheard of for her to travel alone in remote areas, conveying heavy equipment and necessary chemicals, finding her subjects without pictorial precedents to guide her. Her travels took her from her home county of Amador into Alpine County, where high, rugged peaks and ridges, deep canyons, and many lakes characterize the topography. The area was first settled during the gold-silver boom of the 1860s and early 1870s, when a number of short-lived but good-sized towns and mining camps came into existence. She gravitated toward these local communities, including the Exchequer Mine, where she posed the laborers lined up side by side against the scarred terrain and apparatus they used to extract the minerals. A group of surviving stereographs made here reveal her ability to fashion apt visual strategies to convey the distinctive alpine scenery from which the county's name derived. For *Exchequer Cropping* (fig. V-A-1), she positioned her camera near the bottom of a hill and shot the band of miners halfway up the incline, with a craggy outcropping looming above them. Another adopts a vantage point even farther back, providing a sweep from the base of a mountain up to its summit, including a raw, exposed rock surface, a row of men, and a string of buildings, all leading the eye to the uppermost peak. Improvising her formal strategies, she compresses a range of visual information into a pleasing composition.

These images—combination landscape and group portrait—were done as stereographs, photographs shot with a camera made especially to produce two nearly identical images. When mounted side by side and viewed in a special apparatus, they reveal a three-dimensional effect. In the days before moving pictures, these stereographs provided a popular form of entertainment. Likely she made these banking on multiple markets: locally, the mining company and individual workers who wanted to document themselves in the context of the work they were doing, and nationally, those looking for information about mineral resources and investment opportunities in the newly minted state of California.

Witness to the birth of tourism in the region, she also made a specialty of scenic wonders that attracted visitors and the hotels where they boarded. One of her stereographs, inscribed "Kirkwood Summit House" (Amador County Archives), records a structure still standing to this day. A relic of the gold rush era, the Kirkwood Inn was one of the inns along the stagecoach route. It sits amid the pines at about 8,000 feet above sea level, in the shadow of Roundtop Mountain. Another stereograph depicts the Hotel at Silver Lake, just south of Lake Tahoe, the site of spectacular scenery. Here the Old Emigrant Road begins a long loop around Silver Lake basin, reaching 9,640 feet: a road that we know she traveled in order to get her shot. She was ascending to high elevations and overcoming great obstacles to take her photographs, including the necessity of transporting heavy equipment, potentially dangerous chemicals, and large quantities of water in order to make her wet-plate collodion prints. But when the editor of the *Philadelphia Photographer* reviewed a related group of images, the only praise he could muster was a gendered jab: "These are quite remarkable for having been made by a lady, especially when we consider the mountainous region they represent."[103]

To capture these amazing landscape shots, Eliza Withington devised her own mobile photography practice, as well as the apparatus to facilitate it. Fortunately, she outlined her process in her article titled "How a Woman Makes Landscape Photographs," published in a national magazine in 1876 (see appendix 1). Here she instructed her readers on how to prepare a travel-ready kit of equipment to take and develop the photographs. She described her haphazard modes of travel, hitching rides with passersby. And most distinctively, she wrote of using her own "dark, thick dress skirt" as a darkroom tent and her "strong black-line cane-headed parasol" doubling as a shade for the lens and as a walking stick for "climbing mountains and sliding into ravines."[104] Withington left this record for posterity, explaining just how she blazed new photographic trails in the mining camps and scenic lakes of the Sierra Nevada.

Contemplating the New England Coast:
Marian "Clover" Hooper Adams

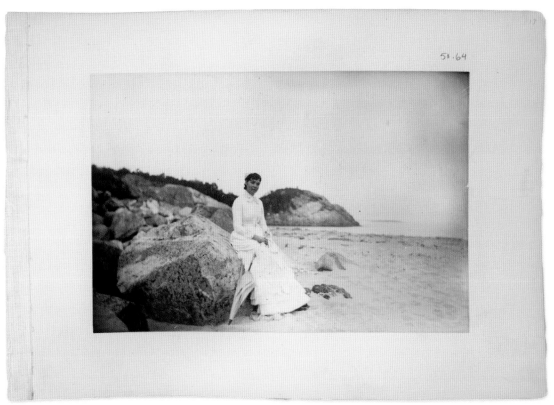

V-B-1 Marian Hooper Adams, *Mrs. Jim Scott Seated on a Rock at the East End of Singing Beach, Manchester,* albumen print, 1883, Massachusetts Historical Society, #50.64, album 8, p. 17

One summer day in 1883, Marian Hooper Adams (1843–1885)—known to her friends as "Clover"—carried her camera to Singing Beach in Manchester, a town on the north shore of Massachusetts. There she took a photograph of her companion, Mrs. Jim Scott, seated on a large boulder at the east end of the beach, looking directly at the camera (fig. V-B-1). Earlier in the century, landscapists, including John F. Kensett, had painted on this very spot, and later family associate John LaFarge would create one of his stupendous stained-glass windows, *The Fish and Flowering Branch* (ca. 1890, Museum of Fine Arts, Boston), for Gordon Abbott's nearby mansion. For her contribution to this distinguished lineage in American art, Adams created a photograph articulating the interrelationship between the female figure and this tranquil coastal location, not far from where she had grown up in Beverly. There is a subtle air of Emersonian transcendentalism in its evocation of nature, perhaps an inheritance from her mother—who died when Clover as five years old and who published her poetry in the magazine *The Dial*, edited from 1842 to 1844 by Ralph Waldo Emerson.

In 1872 Clover married Henry Adams, the grandson and great-grandson of presidents, and an important writer and observer of American political life. During their honeymoon while traveling down the Nile, they took up photography together. After their return they settled in Washington, DC, where she became a famous hostess. By 1883 she acquired a new camera and kept apace of the latest advances in printing and developing photographs, progressing from albumen prints to the platinotype. This new process was a demanding one, but the resulting image—which was based on the light sensibility of iron and platinum salts—demonstrated a matte finish and subtle shades ranging from gray to deep black. She kept meticulous notes on her photographs, from the initial shot through the chemical processes used to develop them. Her husband discouraged her from publishing or selling her photographs, which she organized into red leather-bound albums, carefully ordering them in personal relationship to one another.

Just as she was coming into her own as a photographer, her beloved father passed away, plunging her into a deep depression. By December 1885, while at the home she shared with Henry on H. Street in Washington, DC, she ingested the potassium cyanide she used to fix her images, and died. Preferring to avoid further reference to her in speech or writing, Henry Adams commissioned his friend, the sculptor Augustus Saint-Gaudens, to create a memorial to mark her resting place in Rock Creek Cemetery in Washington, DC. Lacking inscription or date, the mysteriously shrouded bronze figure has become one of America's most famous cemetery monuments.

The means of Adams's art, as her biographer Natalie Dykstra phrases it, became the means of her death. She was one of a number of artists whose death came at the hands of their materials. This includes one of photography's founding figures, J. L. M. Daguerre, whose extended exposure to the poisonous mercury vapors he used developing his daguerreotypes likely brought about his demise. It extends to later twentieth-century sculptors Eva Hesse and Luis Jimenez, who were similarly victims of their artistic materials. Most biographical accounts of Marian Hooper Adams melodramatically emphasize her dark fate. But it is important to remember that even as she was careless with her own life, she took great care to preserve her photographic output for future generations. More attention needs to be paid to that meditative photographic legacy.

Recording History in San Antonio, Texas: Mary Jacobson

San Antonio, with its rich history and distinctive scenery, was the most photographed city in the state of Texas throughout the second half of the nineteenth century. Among the many individuals who turned their cameras on the Alamo, Spanish colonial buildings, and markets was one woman: Mary E. Jacobson, who maintained a studio at 2 East Houston Street and often identified herself as M. E. Jacobson in the male-dominated field.[105] Although little biographical information has yet to surface about her, we can deduce a good deal from the rich cache of her surviving images and current interest in the photographic record of the place.[106] "We have no city, except, perhaps, New Orleans, that can vie, in point of the picturesque interest that attaches to odd and antiquated foreignness, with San Antonio," declared Frederick Law Olmsted—designer of New York's Central Park—in his 1857 travelogue. "Its jumble of races, costumes, languages and buildings . . . combine with heroic touches in its history to enliven and satisfy your traveler's curiosity."[107]

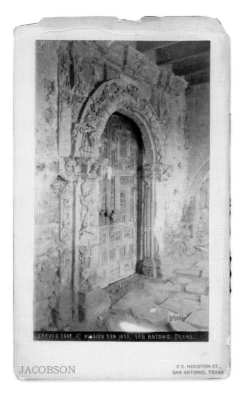

V-C-1 Mary Jacobson, San Antonio, Texas, *Carved Door at Mission San Jose*, albumen photograph, ca. 1890, private collection

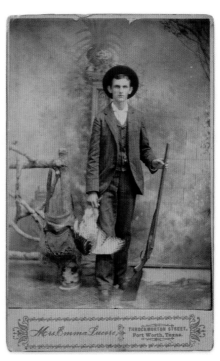

V-C-2 Emma Hollister Lucore, Fort Worth, Texas, *Man with Gun and Game*, cabinet card, ca. 1890, private collection

Jacobson's pictures verify Olmsted's observations, arranged in sets such as "Picturesque San Antonio" that surveyed its Mexican citizens, landscape scenery, and Franciscan missions (fig. V-C-1). Especially after the railroad connected San Antonio with the national network in 1877, tourism flourished, and with it the demand for souvenir images. Visitors from other regions of the United States wanted mementos from what they regarded as a strange and exotic city, with its Catholic churches and Spanish colonial plazas crowded with people of African, Mexican, and European descent. So while Mrs. Emma Lucore took studio portraits of local citizens, including this young man with his gun and game (fig. V-C-2), Jacobson carried her view camera from one architectural site to another and took pictures that possessed a dual appeal for the tourist market by simultaneously documenting the reality and preserving the myth.

In the nineteenth century, as Americans searched for a romantic past, they looked to the crumbling missions as the equivalent of the ruins of the Old World. Many painters as well as photographers undertook projects documenting a series of these structures, sometimes covering the entire state. To chronicle the chain of five missions established along the San Antonio River in the eighteenth century—the largest concentration of Catholic missions in North America—became Jacobson's goal. A favorite motif was the large Mission San José, located on the banks of the San Antonio River a few miles south of the earlier mission, Mission San Antonio de Valero (the Alamo). Mission San José (or Mission San José San Miguel de Aguayo) was founded in 1720 by Franciscan missionaries. Like other Spanish colonial missions scattered throughout the Southwest and California, it was conceived as an agro-religious complex where the clergy lived, worked, and worshiped with the native people. Completed in 1782, its imposing complex of stone walls, bastions, granary, and church attracted a number of photographers. "It was the most elegant and beautiful of the Texas Missions," reads the descriptive text Jacobson published with her photographs. Her *Carved Door at Mission San Jose* captures at an angle the face of the door and decorative archway above. "The celebrated artist Huica was sent from Spain and spent several years in carving the various ornamentations of the building," the caption explained. "The front doorway is 35 feet high; the doors, solid live oak covered with cedar, nicely carved." But ca. 1890, when she took this picture, it was in a bad state of decay, and she predicted that "between the elements and the festive vandal," it "will soon be no more."[108] Photographs like this one preserved the appearance of its nearly lost details and stimulated efforts to save the mission, which in the 1930s was almost fully restored by the WPA (Works Projects Administration).

Straddling California & Mexico: Sarah Short Addis

Sarah Short Addis (active ca. 1875–1890) fashioned a picture-making practice that straddled California and Mexico. The daughter and wife of professional photographers, she learned the technology and business from them. Their achievements, however, have long overshadowed hers. The patriarch Thomas Joseph Short worked as a daguerreotypist in Lawrence, Kansas Territory. In 1855 he hired an assistant named Alfred Shea Addis, and a year later Alfred and Sarah were married and shortly thereafter moved to Leavenworth, where they remained until about 1864, maintaining a photographic studio. Between the mid-1860s and the mid-1880s they were so peripatetic that their locations are difficult to track, but for several years, from about 1874 to 1878, they worked in and around Los Angeles. Although Sarah's name does not appear on the card backs or advertisements for their studio, it is certain that she assisted her male relatives.

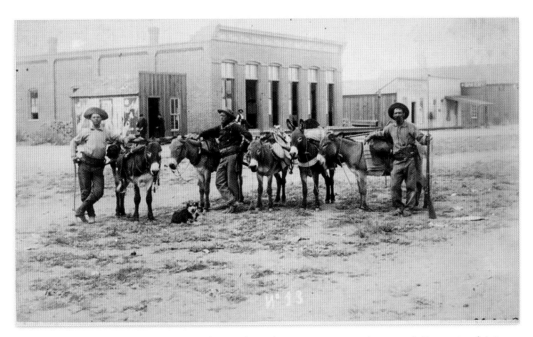

V-D-1 Sarah Short Addis, *Men in Chihuahua with Donkeys*, ca. 1875–90, cabinet card, University of Arizona Libraries, Mrs. A. S. Addis Photographic Collection, MS 486.

Upon the death of her husband in 1886, Sarah took over the family studio in Mexico and thereafter produced primarily cabinet cards with her moniker "Mrs. A. S. Addis Chihuahua, Mexico" printed on the front. Her extant work includes images of the indigenous people who themselves moved back and forth across the border.[109] Many of her images take on the look of genre scenes of women engaged in everyday activities, such as making tortillas or washing clothes. *Indian (Tarahumara) Women Washing Clothes Outdoors* positions the viewer on the near shore of a shallow stream that cuts horizontally across a landscape with mountains in the distance. The women seem to go about their tasks without paying attention to the photographer.

Another cabinet card shows a picturesque street scene in Chihuahua with a line of cowhands and their trusty donkeys (fig. V-D-1). The men stop to pose in the middle of one of the streets in the town, allowing the opportunity to survey their characteristic attire and the heavy packs the animals carry. Highly salable, cabinet cards were collected as tourist souvenirs but were also marketed as sets for the armchair traveler who wished to experience foreign people and sites vicariously. We can imagine Addis's photographs inserted into albums assembled by women for the edification and viewing enjoyment of their families. She provided a female perspective by focusing on work performed by indigenous women, whereas her male counterparts often photographed their semiclad bodies as exotic objects of display.

In the face of scant information about Sarah Addis, this report from the Los Angeles press in 1889 about her daughter Yda Hillis Addis provides some background into their shared lives:

> Her knowledge of the Spanish language enabled her to do good work in the schools where that was the vernacular of many of the pupils. Miss Addis showed her literary aptitude both in poetry and prose. Her delineations of Spanish types of characters in her stories in the *San Francisco Argonaut*, and other journals, which have been widely copied; her terse and often dramatic presentations and analysis of the action of the persons and episodes she describes; her picturing of Mexican traits and customs in various American newspapers, since her residence during the last three or four years in the City of Mexico; and finally her discovery of the lost art of lustering "Iridescent Pottery" as described by her and Mr. W. C. Prime, in *Harper's* magazine for Aug. 1889, have combined to give her a national reputation. Her kindly appreciation of Mexican character, her talents and her personal worth have given her the entre [*sic*] to some of the best families in Mexico.

What we know is that Sarah Addis, like her daughter, experienced this border region differently from her male contemporaries. Through their gendered texts and images, they found their voice and inserted alternative subjects and observations into the photographic record of California and Mexico.[110]

Riding the Rails: Mary Jane Wyatt of Holdrege, Nebraska

The life story of Mary Jane Sears Wyatt (1840–1918) demonstrates how effectively women were able to engage with photography as a means of making a better life for themselves and their families. According to the US census of 1860, she was an unwed mother trying to support herself and her young son as a domestic servant in Ohio. Determined to move west and make a fresh start for both of them, she relocated to the small prairie town of Roseland, Illinois, where by 1878 she had married a man named Andrew A. Wyatt and was advertising

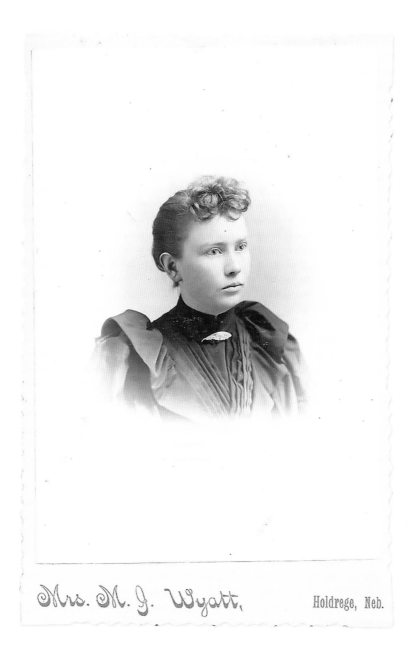

V-E-1 Mary Jane (Mrs. J. J.) Wyatt, Holdrege, Nebraska, *Young Woman*, cabinet card, ca. 1883–90, private collection

her Wyatt's Art Gallery. Within a few years we find them in Nebraska, where Holdrege became her base of operations as she strove to become a successful traveling photographer. Soon she conceived the idea to acquire a railroad car, in which she set up her studio and rode the rails, finding clients in the string of small towns located along the rail line. In this she had the support of her husband, who was an engineer for the Burlington Missouri River Railroad (and later a sheriff). For three decades she reigned as the only woman photographer in Nebraska to have a traveling studio car on the state train lines, making portraits of the early residents and scenic views of the terrain where they lived and worked.[111] She is one of a handful of women nationwide who broke female stereotypes by taking to the road and becoming an itinerant photographer.

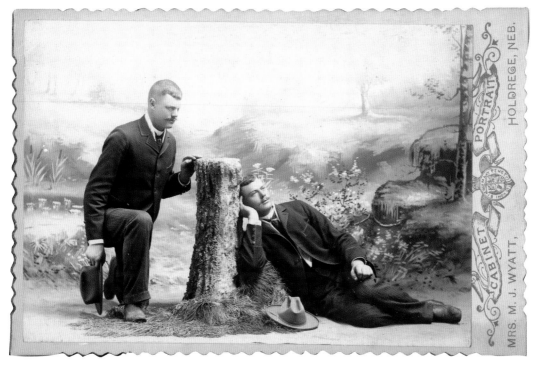

V-E-2 Mary Jane (Mrs. J. J.) Wyatt, Holdrege, Nebraska, *Double Male Portrait against Scenic Backdrop*, cabinet card, ca. 1883–90, private collection

Swedish immigrants settled the town of Holdrege in the 1880s. It took its name from George W. Holdrege, general manager of the Chicago, Burlington & Quincy Railroad Company, who constructed most of the line's mileage in Nebraska. On December 10, 1883, the first train arrived in Holdrege, a tiny pioneer town of 200 people at the time.[112] Moving to this small, fledgling town and setting up a studio, Wyatt—like many female photographers—banked on the hope that the town would grow and have a need for a local photographic business that would expand with the fortunes of the town. On March 1, 1887, the *Nebraska Nugget* reported that Mrs. Wyatt "has gained a very flattering reputation as one of the finest artists in the country, and her business is increasing to such an extent that the car is insufficient for her extensive work." Clearly the local townspeople regarded her as an integral member of the community. Her bust-length image of a young woman with a broach at her throat is representative of her traditional portrait work (fig. V-E-1).

The railroad was central to the history of the region, so it is not surprising that it played such a key role in the career of Mary Jane Wyatt. Some of her male contemporaries enjoyed the use of private railroad cars, including the well-known western landscape photographer William Henry Jackson, who traveled along the lines, stopping to photograph at desired locations along the way. But while he was the recipient of many commissions within the industry, she does not seem to have worked directly for the railroad. Instead, she evolved the creative solution to utilize a train car while working independently with individual sitters.

Visiting her portable studio in the railroad train car must have been an unusual if not a unique experience for her clients. It is possible that the space—so distinct from the usual in-town photographic establishment and removed from local residents and conventions—became a place of performance and play. Surveying photographs taken over the course of her career, it is evident that she used scenic backdrops and screens to provide settings for her sitters. This practice in itself is not unusual, for as we have seen, many photographers used a painted backdrop for portraits. But Mrs. Wyatt's painted scenery demonstrates greater variety and was often combined with props, as if she was trying to encourage a bit of fantasy in her Nebraskan neighbors. Consider the cabinet card in which she has either printed two exposures of the same person onto a single image or photographed twins to appear as if in they are in an open landscape (fig. V-E-2). The two light-haired men in suits flank a cut wooden stump, with the figure at left kneeling on one knee, with one hand lightly resting on the stump, while the second figure reclines at right, his elbow bent and chin resting on his hand. What is going on in this scene, where the reclining figure stares dreamily off into the distance while his double appears to be genuflecting in respect? Perhaps they are remembering a lost loved one, an interpretation that is reinforced by the fact that they have both removed their hats in a gesture of respect. Exactly what message is intended in this scene goes unrecorded, but Mrs. Wyatt definitely demonstrated more than the usual degree of inventiveness.

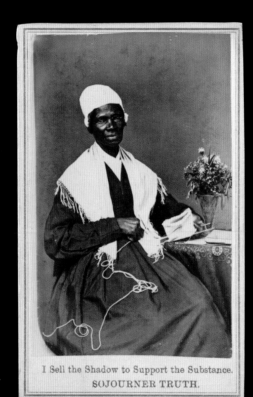

I Sell the Shadow to Support the Substance.
SOJOURNER TRUTH.

Chapter VI
THE NEW WOMAN & WOMEN'S RIGHTS
Introduction

Women in America during the eighteenth and early nineteenth centuries found their primary expressive vehicle in the printed word, as Lori Ginsburg explains:

By the 1830s, the written word had long constituted an essential means by which women assured [*sic*] their place in civic life. Many women who wanted their views heard in the realm of public discourse wrote tracts, articles, fictional short stories, and novels, as well as authoring and presenting political speeches. Written and read largely by middle-class women, magazines such as *Godey's Lady's Book*—packed with fashion plates and patterns, fiction, domestic advice, and reports by travelers throughout the world—circulated widely. While female authors may have enhanced women's public authority, by no means did they all support what were known as woman's rights. Catharine Beecher, most famously, articulated a vision of American society that was both hierarchical and gendered—and that underscored women's dependence—through her domestic advice manuals as well as in publication's opposing women's antislavery activism.[113]

VI-IN-1 Photographer unidentified, *Sojourner Truth, carte de visite*, 1864, Metropolitan Museum of Art, New York

In the same time frame, the possibility of female visual artists was hardly entertained, except perhaps as amateur watercolorists or silhouette makers. But then an extraordinary series of events unfolded.

On January 7, 1839, Louis-Jacques-Mandé Daguerre demonstrated an invention that forever changed the nature of visual representation: photography. His daguerreotype (as his invention was named) was a one-of-a-kind image on a polished silver-plated sheet of copper. It happened that Samuel F. B. Morse—best known as the creator of the telegraph and the Morse code—was in Paris at the time and soon brought the secrets of Daguerre's process back to America, including camera equipment and how-to instructions.

On July 19 and 20, 1848, the first women's-rights convention was held in the US. Organized by Elizabeth Cady Stanton and Lucretia Mott, the gathering of about 300 people, including forty men, took place at the Wesleyan Methodist Church in Seneca Falls, New York. Stanton assumed the task of drafting a Declaration of Sentiments that would set the agenda for the meeting. Taking the Declaration of Independence as a guide, she stated that "all men and women had been created equal," and proceeded to draft parallel resolutions, arguing that women had the natural right to equality in all spheres. The ninth resolution, considered the most radical, asserted that it was the women's duty to secure for themselves the right to vote. One hundred women and men signed the Seneca Falls Declaration, although subsequent criticism caused some to remove their names. Editor James Gordon Bennett printed the entire Declaration of Sentiments in his *New York Herald*. Motivated by derision, its publication served the larger purpose of informing its huge readership of the cause of women's rights.[114]

So as women began to spread their wings and seek occupations beyond the care of the home, the newly invented medium of photography held out promise. Soon they were learning the secrets of the technical processes that succeeded the daguerreotype, including the ambrotype, tintype, and albumen print. Growing on the horizon as the women's-rights movement was gaining momentum, photography offered women not only a variety of respectable employment options, but also a way to promote themselves and their political cause in pictorial terms. Amelia Bloomer had her picture taken during a speaking tour to make people more aware of the need for reform in women's tight-fitting corsets and impractical clothing. An escaped slave who became an advocate for women, abolitionist, and orator, Sojourner Truth sold cdv portraits of herself at her lectures and by mail to earn money. Inscribed "I Sell the Shadow to Support the Substance. Sojourner Truth," they were widely collected (fig. VI-IN-1). This African American woman fashioned her public image to promote racial and gender equality and, in so doing, endowed photographic portraits with monetary value.[115] In the 1880s and 1890s, women took advantage of the new technologies and streamlined camera outfits to work outdoors, enjoying a new sense of freedom. These are just a few of the many examples of those who posed for their portraits, took pictures of rallies and parades, and found myriad other ways to deploy photography to advance the rights of their sex until 1920, when the Nineteenth Amendment to the US Constitution was passed, and women gained the right to vote.

Dress Reform: Amelia Bloomer

In mid-nineteenth-century America, debates swirled over female dress, and the outfit featured in this photograph by Mrs. N. L. Rowley was at the center of the controversy. Rules of the day dictated that a lady's dress had to be floor length, with a full skirt and a narrow waistline. To comply, middle- and upper-middle-class women squeezed themselves into corsets and donned as many as eight petticoats, adding an extra 15 pounds to weigh them down. Laced corsets and whalebone stays impaired breathing, caused overheating, and constricted or deformed internal organs. For pregnant mothers, the risks were even greater. Given also the filthy, rutted streets prevalent in most cities at the time, cartoonists often poked fun at properly attired ladies with their billowing skirts sweeping up garbage as they walked. Clearly, women were having a difficult time maintaining both modesty and a fashionable appearance. But what were they to do?

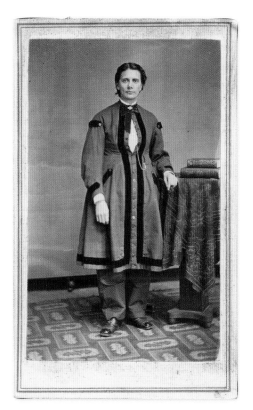

VI-A-1 Evangeline (Mrs. N. L.) Rowley, Hudson, Michigan, *Amelia Jenks Bloomer, carte de visite,* mid-1860s, private collection

Then, in February 1851, Amelia Jenks Bloomer—editor of a pioneering woman's newspaper called *The Lily*—ran a series of articles that seemed to offer a solution. What if women switched to "Turkish pantaloons and a skirt reaching just below the knee"? Shortly thereafter, Elizabeth Cady Stanton received a visit from her cousin Elizabeth Smith Miller, dressed in the very ensemble Bloomer had described in her article. Soon Stanton and Bloomer had identical outfits made for themselves and resolved to dress only in the new reform style, as Bloomer announced in *The Lily*. To demonstrate her point, she accompanied the article with a portrait of herself so attired (fig. VI-A-1). Almost immediately, women all over the country wrote to her, asking for patterns so they could rid themselves of the burden of long, heavy, and uncomfortable skirts. The trend caught on, and, despite Amelia Bloomer's protests that she was not the originator of the new garment, they became forever known as "bloomers." Women nationwide were moving more freely and comfortably in the many versions of the pantalets. All too soon the tides turned against them, however, and they were forced to rethink their fashion choices.[116]

Writing *The History of Woman Suffrage* years later, the authors (including Elizabeth Cady Stanton and Susan B. Anthony) suggested at least one reason why the trend was short lived: "No sooner did a few brave conscientious women adopt the bifurcated costume, an imitation in part of the Turkish style, that the press at once turned its guns on [it]." Trousers on the female form were highly controversial across the Western world at the time. In France, where it was illegal for women to attire themselves in pants, artist Rosa Bonheur was forced to obtain a special permit from the police—renewable monthly—so that she could wear them when she visited farms and stables to paint the horses and cows that were her principal subject.[117] In the United States it technically wasn't illegal, but the women faced so much ridicule, from men in the streets to the press, that they soon retired their pantaloons and short skirts and returned to their pinched waists and long, full skirts—the only consolation being that the advent of crinoline in the interim at least made the petticoats lighter. While there has been much speculation about exactly why bloomers raised such objections, an article in the *New York Times* in 1852 expressed the base fear that lay behind men's reactions toward this latest female clothing trend:

> These ladies assert their claim to rights, which we of bifurcated raiment are charged with usurping. This claim conflicts with, and if secured, will tend to diminish the rights of masculine mankind. . . . But the ladies go still further, and he must be blind who does not perceive in these low murmurings a storm that shall eventually rob manhood of all its grand prerogatives.[118]

Fearing that this focus on fashion would detract from larger issues of gender equality and the vote, women's rights leaders abandoned pants and short dresses for their former mode of attire. But bloomers lived on, nurtured by advocates of health reform, through the 1860s.[119] This explains then why a portrait of Bloomer wearing her characteristic attire would be popular in cdvs of the 1860s.

This *carte de visite*, identified on the verso as the work of "Mrs. N. L. Rowley, Hudson, Michigan," documents one variation on what was for a time called the "freedom suit." Although the sitter is not named on the card, comparison with confirmed portraits of Amelia Jenks Bloomer makes the identity here virtually certain. The

question then becomes how did she come to sit for this female photographer living in the village of Hudson in southern Michigan? Bloomer was active not only in dress reform and the woman's movement, but also for the related cause of temperance. She was a popular speaker on the lecture circuit, traveling from city to city to enlighten her audiences on the need for women to have the right to vote and dress as they choose, and on the evils of alcohol. Over the course of the 1850s she delivered her lively lectures with increased frequency, moving around the Midwest with stops at Cleveland, Columbus, Indianapolis, Detroit, Chicago, Milwaukee, and other locations in an effort to spread the word. We know that she was in Detroit—about 100 miles from Mrs. Rowley's studio in Hudson—in 1853, as described in the press that October: "Amelia Bloomer Lectures on Women's Rights at Detroit's Firemen's Hall." We know that she wore her signature bloomers on these lecture tours and continued to favor that apparel long after others in the women's rights movement had abandoned it. So we might assume they met in Michigan, but when? Disderi did not patent the *carte de visite* in France until 1854, and it did not come into widespread use in the United States until the late 1850s, when C. D. Fredericks introduced it in New York City. So it reached Michigan ca. 1860. It's possible, therefore, that on a return visit to Michigan in the early 1860s Bloomer sought out a female photographer for her portrait. Another scenario is that someone else took an ambrotype photograph of Bloomer on her 1853 trip to Michigan, and then Mrs. Rowley—perhaps in her enthusiasm to support Bloomer's causes—made cdvs after the ambrotype, a method of duplication that we know other photographers practiced.

Sadly, Mrs. N. L. Rowley is another of the many women who are known to us only through a handful of surviving photographs and a few scant records. She is likely identifiable as Angeline Rowley, who was living in Hudson with her daughter Arvina during the years 1862–1870, as documented in Michigan business directories and Internal Revenue records, which indicate that she was affixing the required two-cent revenue stamps to the reverse side of photographs she took during the Civil War years.[120] There is every likelihood that she was active before and after that, but records located to date stop there.

While many cdvs focus on the sitter's head and shoulders, in this case the subject was shot in full figure with the camera sufficiently distant from her to convey her entire ensemble, featuring the short dress with its contrasting piping, and pants protruding from underneath it. Studio props are kept to a minimum: a plain wall, geometric-patterned floor covering, and a cloth-draped pedestal, upon which sit several books, allow the figure to dominate the space. But Rowley did make one interesting addition: the subtly patterned tablecloth has been hand-tinted a rich magenta, either by her or an assistant. That one touch of color contrasts with the gradations of sepia tones that saturate the rest of the image, and calls attention to the lower half of the picture. There, the legs extending from under the tablecloth to the base parallel the usually hidden legs of the woman protruding from below her short dress. This subtle pictorial device ensures that the viewer will definitely notice the wearer's bloomers!

Lowell Mill Girls' Heirs: Costillia Smith

Lowell, Massachusetts, had been founded in the 1820s as a planned town for the manufacture of textiles. It was here that Costillia Smith ran her own successful portrait studio for almost thirty years (1877–1905).[121] Textile mill owners recruited young women to work, typically daughters of propertied New England farmers between the ages of seventeen and thirty-five. At the height of the Industrial Revolution in 1840, the Lowell textile mills employed over 8,000 workers—mostly women—including, most likely, the photographer's own sisters.[122] Forced to work extensively long hours under poor conditions, the women organized a campaign in 1845 to petition

VI-B-1 Costillia D. Smith, *Child Standing on Chair with Paisley Drapery*, cabinet card, ca. 1880–89, private collection

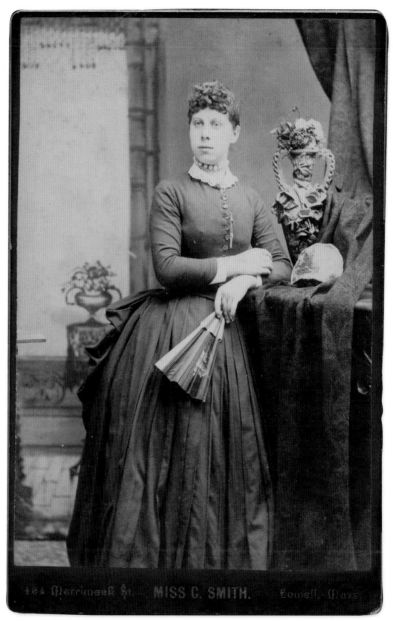

VI-B-2 Costillia D. Smith, *Standing Woman with Fan*, cabinet card, ca. 1880–89, private collection

the Massachusetts state legislature to cap the work day at the mills to ten hours. Debates about the Lowell Mill Girls, as they were called, were waged in the press. Only late in the century would photographers such as Jacob Riis or Lewis Hine enter factories to document the horrific physical environments. Earlier, the Mill Girls were documented in images ranging from portraits of a single individual to groups of women with raised fists banded together in solidarity to improve their labor conditions.

It was in this environment that Costillia Smith first apprenticed around 1870 under a photographer named Moses Emerson, and probably learned photographic skills from him before branching out on her own in 1877. She was remarkably prolific and made more than a thousand portraits in the cabinet card format, which bear

the name and addresses of her studio, indicating that she routinely changed addresses within the town, but often along the busy thoroughfare of Merrimack Street. Consider, for example, her portrait of a young child standing on a chair with a paisley drape behind (fig. VI-B-1). It demonstrates a deft hand with posing, so that the small figure does not get lost in the space but at the same time conveys the innocence of a child.

Smith modified the formatting of her name several times. On her cards she signed herself "Miss C. Smith," while in city directories and other documents she initially identified herself as Costillia Smith and, after 1884, added the middle initial *D*, probably a reference to the middle name D'Lacost, which appears on her death certificate. According to Lee McIntyre, who blogs about early women photographers, around the same time that she added the *D* to her name, she hired a French-speaking camera operator named Hormidas T. Dillette. She also began listing her name as Madamoiselle and her studio address in both English and French on the cards themselves, and in advertisements. As McIntyre logically speculates, the insertion of the addition of the French language must have been done in the expectation or hope of attracting a French-speaking clientele.[123] In the 1870s and 1880s, my research indicates, French Canadians began moving to Lowell in a new wave of migration, seeking work in the textile factories and settling in an area of the city that was dubbed Little Canada. Looking into the unidentified faces of some of Smith's sitters, we are likely confronted with some members of that French Canadian community.[124] One standing female portrait is typical of the balanced composition and technical quality that were the hallmark of her work (fig. VI-B-2). Smith lends the woman a sense of propriety by having her hold a fan in a nicely appointed setting with fine wooden furniture and decorative arts. She utilized a painted backdrop with flowers and vase to echo the vase on the table and reinforce the feminine touch. But regardless of their precise identity or ethnic background, the mostly female sitters who came to Smith's studio could be conceived of as the heirs of the Lowell Mill Girls—young women like her own sisters who worked hard not only to earn their own livelihoods, but also to improve labor conditions for subsequent generations.

Swedish National Identity in Chicago: Anny Lindquist

About 1890, Anny Lindquist (active 1889–1917) made a particularly striking portrait of a young woman in bust length (fig. VI-C-1), facing off to her right. The photographer posed her in a dark-colored dress against a dark background so that her porcelain-white skin and blond curls brushing her shoulder emerge out of the shadows. A corsage of white flowers centered on the collar of her dress provides the only other light accent, drawing the viewer's eye up to her face and—in an age-old trope—playing off the beauty of the flower with that of the female sitter. The subject's features and coloring suggest that she, like the photographer herself, was of Swedish descent, either an immigrant or the child of immigrants. Having arrived in Chicago in 1887, Lindquist set up a studio two years later at 330 East Division Street, where this photograph of an unidentified woman was taken.[125] The address places her near Chicago's North Side, where those who had recently arrived in the Windy City from Sweden lived together. Like many who moved to America from Europe in these years, the photographer gravitated to the neighborhood where others of her background had arrived before her, and likely received advice and perhaps even initially boarded with folks she or her family had known back in the old country.

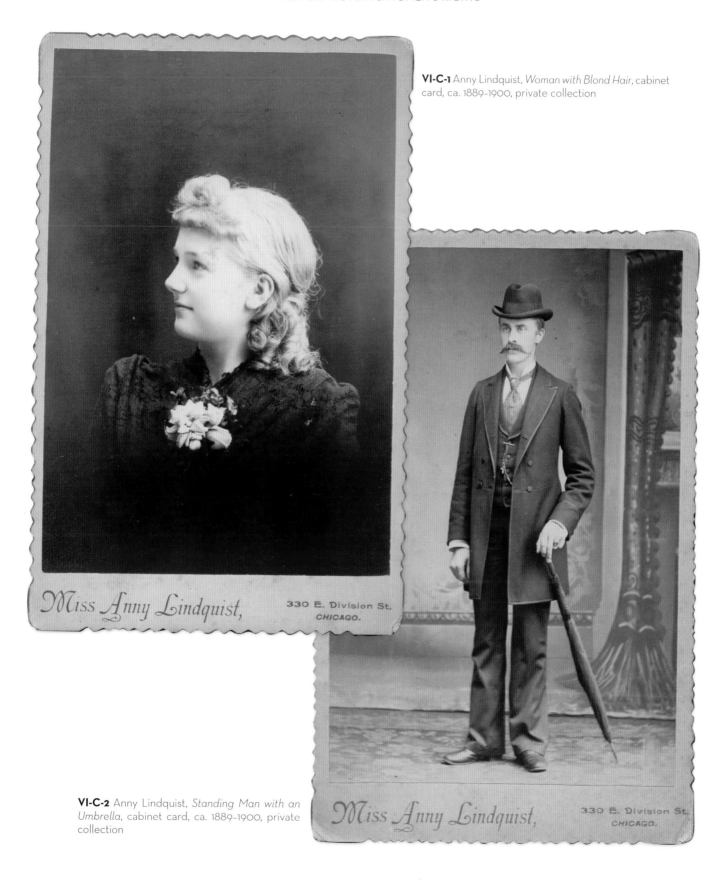

VI-C-1 Anny Lindquist, *Woman with Blond Hair*, cabinet card, ca. 1889–1900, private collection

VI-C-2 Anny Lindquist, *Standing Man with an Umbrella*, cabinet card, ca. 1889–1900, private collection

Lindquist further strengthened her ties to this expanding community in 1895 by entering into a partnership with Hannah Berglund, who had emigrated from Sweden to the United States in 1880. As the firm of Lindquist & Berglund, they operated together for about fifteen years, using painted backdrops as well as decorative arts and furniture from their own homes to enhance their portraits.[126] Props such as fans or vases of flowers for women and canes or books for men helped vary photographic portrait conventions and convey respectability and character through small personal touches. Consider the case of a gentleman who walked into their studio attired in a dark suit complete with cravat and watch fob (fig. VI-C-2). Before shooting his photograph, Lindquist handed him an umbrella and positioned it with the shaft extending at an angle, providing a prominent diagonal line to contrast with the strong verticals throughout the composition, and thus conveying dynamism in an otherwise static composition. In these and myriad other ways, Lindquist and Berglund aimed to enhance the status of their sitters both individually and collectively as Swedish Americans.

In 1894, just before Lindquist joined forces with Berglund, an article titled "Women Who Do Men's Work" appeared in the *Chicago Daily Tribune*. Among its list of professions considered "men's work" were undertakers, barbers, dentists, and photographers, including a mention of Anny Lindquist. "All of these young women got into the business by studying it from the ground up and investing a little capital," we read. The article was based on the premise that women were by then breaking into what was labeled as "men's work." But this claim, as we have seen, was simply not true. Women were active behind the camera from the beginning, and their numbers were growing. "The eternal fitness of women for this particular business," the author continues, "will be readily seen." Paradoxically, he then relegates them to a small number of specialties on the basis of sexist assumptions: "Women are natural flatterers and many a homely young man has spent an ecstatic half hour with the girl who made him believe, for the time being, that he was an Adonis."[127] What limited success the author attributed to them, in other words, was based on their ability to manipulate innocent babies and un-suspecting (and homely) males. Writing toward the century's end, this journalist reflects mounting fear of the power that women had gained in the field, which was highlighted in the photographs displayed in the Women's Pavilion at the World's Columbian Exposition held in Chicago the previous year. Camouflaged as a pat on the back to women who were branching out professionally, the article was in fact part of an insidious campaign to diminish women's professional standing and restrict them to a discrete corner of the market. However condescending the prose and contradictory the rhetoric, this author was acknowledging that by the 1890s, women photographers had become a strong force with which the men had to reckon. But perhaps there was more than gender bias at work. Given that Lindquist was cited in the article, it seems possible that her status as a recently arrived immigrant was also at issue. The 1890s were a time of increasing xenophobia and anti-im-migration legislation in the United States. The fact that Lindquist and her partner were linked by nationalistic ties with their Swedish American sitters, whom they portrayed as attractive and upstanding future citizens, was likely another source of anxiety in their adopted country.

Advertising Photography: Beatrice Tonnesen

In the fall of 1896, a twenty-five-year-old female photographer left her native Wisconsin for Chicago and emblazoned "Beatrice Tonnesen, Photographer" in big gold letters on the plate glass window of her studio at 1301 South Michigan Avenue. Described as vibrant and beautiful, she was from genteel background, with artistic training and sufficient financial backing to allow her to set up an impressive studio that attracted elite clients from the Prairie Avenue neighborhood.[128] "I always wanted to be a business woman, and I didn't care to give up my art," she explained, "So I combined the two, and so far it has proved to be a successful combination."[129] Soon the city's rich and famous were lining up to sit for her, and social and artistic leader Bertha Palmer helped get her appointed as the representative of US photography at the Paris Exposition of 1900.[130] Not content, Tonnesen had an idea: Why not use live female models to make photographs for advertising, a field still in its infancy? This and other ideas earned her a reputation as being among "the most influential graphics people of the last millennium," and observers praised her for producing work that "is totally distinct from all that has gone before it" and that "inaugurates a new era in advertising illustration." Yet, her name is still barely recognized in photographic circles.[131]

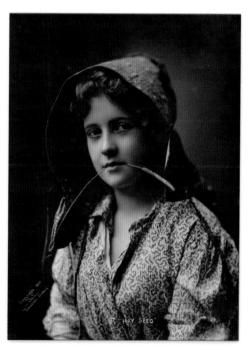

VI-D-1 Beatrice Tonnesen, *The Hayseed*, albumen photograph, ca. 1890s, private collection

Beatrice Tonnesen (1871–1958) was among the second wave of commercial female photographers who appeared on the scene in the 1880s and 1890s. At the time, she was still working with the cabinet card format but afterward transitioned to gelatin silver prints. In 1897 *Godey's Magazine* featured Chicago photographers Sallie Garrity and Beatrice Tonnesen in an article titled "A New Profession for Women."[132] Like many hopeful females who moved to Chicago in search of opportunity, Tonnesen was single and eager to forge her own career path. Unlike them, she had initially trained as a painter, which helped develop her eye for composition and sitters. For a time she partnered with her sister Clara, but she was the creative and promotional force behind their work.[133] She helped create the new genre of advertising photography from the ground up and thrived for a time in the male-dominated field. Among the lucrative offshoot to advertising photography she promoted was the production of photographs for company calendars. Her records indicate her commissions from Brown & Bigelow of St. Paul, one of the largest calendar firms of the day, as well as individual companies such as the Exchange Bank of Ohio. She varied her visual style to suit the client's needs and tastes, such as the International Harvester series that featured country scenes and figures dressed up to look like agricultural works, with props such as haystacks. *The Hayseed* (fig. VI-D-1) likely belongs to that series, featuring a bust-length portrait of a young woman in a bonnet and rustic print dress, with a strand of wheat between her teeth. Tonnesen was working with the common trope of attractive, athletic women acting out seasonal narratives, which had been a staple in fine arts since the Renaissance, but now with the modern twist of the photographic medium.

Advertising photography was made possible by the late 1890s through improvements in half-tone printing and became a niche business on the rise. Being in the right place at the right time, Tonneson's business soared as Chicago grew into a retail hub. She counted among her local customers catalog retailers Montgomery Ward and Sears, Roebuck & Co., and the department store Marshall Field & Co. Meanwhile, her national customers included Kellogg's, Munsingwear, Ralston, and Sun Maid Raisins. Her social ties with financial moguls Potter Palmer and George Pullman further enhanced her business.

Having recognized photography's potential for advertising, Tonnesen took it one step further. She soon gained local and national media attention when she opened a modeling agency (one of the nation's first) to meet the demand for live models, and she was constantly on the alert for fresh faces. Trained in an art school, she would have been accustomed to working from live models and logically extended the practice into advertising. "One of the great factors in the success of the business," one observer noted, "has been Miss Tonnesen's ability in discovering suitable models, both for face and figure, amongst the people—specially the work-girls of Chicago, and inducing them to sit for their pictures."[134] Nor did she confine herself to adults. Another of her brainstorms was what she called "Baby Day," when she induced mothers to bring their babies into the studio for test shots by offering them a free photograph for each shot she could use. Ultimately she commissioned one hundred infants, fifty laughing and fifty crying.[135] She also helped supply artists with models.

Her life was not a complete success story, and she suffered financial failure in later years. Conservative in her demeanor even as she negotiated the business environment competitively, she was not openly supportive

of women's rights and later claimed not to like the "new woman." Given her need to foster professional relations with traditionally minded businessmen, however, she might have adopted this stance as her public face to allow her to function in an environment where a self-proclaimed modern woman was unwelcome. In spite of the challenges presented by unequal gender relations, however, Beatrice Tonnesen forged a unique professional path and fulfilled her goal of synthesizing art and business through photography.

Women's Revenge: Pirie MacDonald's Men-Only Policy

Pirie MacDonald (1867–1942) was a highly successful photographer who began his career in Albany, New York, and then moved on to New York City. His work was especially admired for his technical expertise and ability to capture the character of the sitter, enhanced by his lighting effects that dramatically highlighted the sitter's head and shoulders. He won many awards and prizes both nationally and internationally for his portraits of the rich and famous men of his age, including Teddy Roosevelt. The New York Historical Society holds a collection of 500 of MacDonald's portraits of men made between 1900 and 1942.[136] His earlier work, however, was focused largely on female subjects (fig. VI-E-1). Why he made the switch was a matter of some debate, but this humorous tongue-in-cheek article (reprinted from the original article in 1901) suggests that it was a matter of women's revenge!

VI-E-1 Pirie MacDonald, *Woman*, cabinet card, 1880s, private collection

"Why He Cut the Women Out"[137]

Pirie MacDonald, Portrait Photographer

Washington Life Building, 141 Broadway, New York City

Portraits of Men Only.

Telephone 150 Cortlandt[138]

> Mr. Pirie MacDonald, formerly of Albany, but now of New York City, is a photographer. He calls himself a Photographic Artist – and he is. He has more medals, and gets higher prices than any photographer in America. His prices are as high as a church steeple. Pirie is the only man I ever knew, or heard of, who made a fortune taking photographs. He has his limit in every savings bank in Albany, owns a block of flats, and sports an automobile in the park with a bull-dog sitting beside him. Pirie of the Medals does not take everybody's picture – he picks his customers. As you enter his space he sizes you up through a peep-hole from behind the arras, and if your countenance lacks a trace of the classic, Pirie signals his assistant, & you are informed that Mr. MacDonald is in Europe and will not return for a year and a half.

Mr. MacDonald's specialty until recently has been Society Belles – tall, lissome beauties, proud and haughty with a wondrous length of limb; these are the kind he liked best. And so famous is MacDonald that sitters have come to him from Rochester, Potsdam, Chambersburg, Rahway and all the country 'round and gladly paid the price of one hundred simoleons for one portrait, done with that wonderful Rembrandtesque effect, and signed by the artist. Often Pirie would send the fair one home to change her dress, but if her hair needed re-arranging he always tended to that himself. Pirie's skill lay in posing his sitters so to get the best result. Usually he would sit down with his subject & talk to her about this or that, and tell her stories, pathetic or comic, and all the time he would be watching her countenance and debating in his mind whether he would pose her as a Madonna, Sappho, Judith, Marguerite, or Queen Louise. The Judith-Holofernes pose was his best, but it was often difficult to bring about the feeling that gave attitude. Women want to look pretty, and that wasn't what Pirie cared for: he desired chicity-chic, go, biff and éclat. To this end he often had to resort to a scheme to bring the sitter out of her affected self-consciousness. "Look into my eyes," he would sometimes command; and when all else failed, Pirie would assume wrath, and declare: "Here you are – why in tarnation can't you do as I want you to!" and he would clap one hand on the beauty's head and the other under her chin and give her a few sharp turns to win'ard, and end by administering a sharp slap athwart her glutaeus maximus, to straighten her spine. By this time the woman would be simply furious, and speechless with rage. Then she would sit bolt upright, ready to explode, but she was not given time to go off, for Pirie would step back three steps and shout exultantly "Splendid! Hold that – Hold that!" and then he would rush forward, kiss her on the cheek, and back again he would spring crying, "Hold that! Hold that!" and the bulb was pressed.

And when all was over the artist was so penitent so humble and beseeching in his manner, so profuse in his explanations that it was all in the interests of Art, that all was forgiven for base indeed is that woman who is not willing to sacrifice her feelings on the altar of Divine Art. And thus did Pirie get the most wonderful "Salome," which was the wonder of the Paris Exposition, and was declared by the judges to be the strongest and most effective study in photography ever exhibited. In every line it showed such a fine feminine rage – such pride & smothered passion – that people looked at it in amazement. No one knew that Pirie tumbled the woman's hair in one fell grab, and had aroused her wrath, and then offered her insult by kissing her and so brought that fine look of burning shame and mingled rage to her proud face.

It's a great picture and it will pay you to stop off at Albany the next time you are down that way and go to the State House and see it.

But the Ideal continually recedes, and Pirie having the true instinct of an artist was fired with an ambition to do still better. The opportunity came, & Pirie, looking out through the peep-hole, beheld a woman, say of twenty-eight, five feet eleven, weight one hundred and sixty. Her beautiful and abundant hair was bleached, and she had the proud and self-reliant look of one who had conquests that lay behind, and others, greater still, within her grasp. Her neat-fitting jacket and tailor-made gown showed off her fine form to advantage. The strong features were pure Greek.

Pirie almost screamed with delight, and hastily ordered his assistant to begone and leave the customer to him. "Oh! Now we shall have a real Herodias – that Paris picture will only be a tintype to this. My! What a splendid tiger she is!

That really is all we know about the matter. The attendant improved the opportunity to go out on an errand, and when the neighbors in the law office across the hall heard the commotion and rushed out they caught a swish of skirts and got a glimpse of a tailor-made gown going down the stairway. Pirie was found, panting and helpless, in a corner of the studio, with the black cloth viciously knotted around his neck, and the tripod, camera and sitter's throne on top of him. There was a bad scalp wound extending from one ear to the crown of his head, and it looked as though he had been given a walk to first with the lens.

Pirie never made any statement about the matter, but his card now reads:

PIRIE MACDONALD

PHOTOGRAPHIC ARTIST

Portraits of Men Only

Role Model for Women Photographers:
Frances Benjamin Johnston

In 1893 Americans flocked to Chicago to celebrate the quincentenary of their nation's birth at the World's Columbian Exposition. Among the overwhelming numbers of displays of everything from fine art and industry to popular entertainment and produce gathered from all over the world, one could find the photographic exhibition where women's pictures hung prominently alongside those taken by men. "Unlike the gun, the racquet and the oar, the camera offers a field where women can compete with men upon equal terms," as one critic noted. "And that some women have so successfully striven should encourage more to follow in their lead." Among the women on the writer's mind was Frances Benjamin Johnston (1864–1952), who documented the fairgrounds and its buildings as they were being constructed in pictures that are still treasured as canonical views of that event. The following year she opened her first photographic studio in Washington, DC. And shortly after that—in September 1897—she published a two-page spread in the *Ladies Home Journal* titled "What a Woman Can Do with a Camera" (see Appendix 2).[139] Accompanied by fifteen of her photographs, her text discusses the great promise the field held for aspiring young women. As her willingness to write this article demonstrates, Johnston recognized early on the value of the illustrated press to promote herself and, in so doing, raise people's awareness of the potential of photography. The earlier generation of photographic pioneers had depended in large part on face-to-face interaction with a sitter/client, which resulted in a portrait photograph sold in limited numbers to that single individual. By the time their successors were on the rise, they could rely on new reproductive technologies to circulate their work in newspapers and magazines. Due to her early and enduring success, Frances Benjamin Johnston inspired many women of this second generation to adopt her as their mentor and follow in her footsteps.

At the dawn of the new century, Johnston—dressed in a smart blouse and skirt—posed seated in her studio with one leg crossed over her knee, exposing her petticoat, and tripped her camera's shutter (fig. VI-F-1). Holding a cigarette in one hand and a beer stein in the other, she was casting herself—as everyone at the time would have recognized—as the "New Woman." This photograph became a visual icon of changing gender norms that first emerged in the late nineteenth century. It expressed the autonomy and individuality of younger women who rejected the Victorian mores of their mothers in favor of new, modern choices. Images of fit and active females smoking, drinking alcohol, riding bicycles, and marching for women's suffrage all proliferated in the years from the 1890s to the 1920s, with Frances Benjamin Johnston in the lead.

VI-F-1 Frances Benjamin Johnston, *Self-Portrait Holding Cigarette and Beer Stein, in Her Washington, DC, Studio,* gelatin silver print, 1896, Library of Congress, Washington, DC

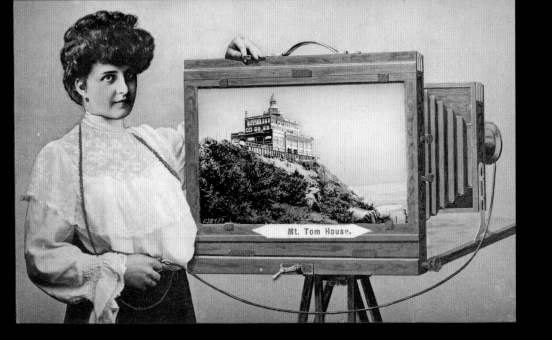

Mt. Tom House.

VII-1 Photographer unidentified, *Woman Photographer at the Mt. Tom House*, postcard, 1890s, private collection

CONCLUSION

A New Photographic Era Dawns: "The Kodak Girl"

The advent of the first Kodak camera in 1888, with its new, more instantaneous process, revolutionized photography forever. It not only opened the field up to a broad array of amateur practitioners, but it also produced a flood of easy-to-snap images that attracted wider audiences to the joys of the medium. Before 1888, a woman who wanted to photograph while she was on the move had to employ traditional, complex methods. Transporting herself via wagons, carriages, and trains, she carried a large and heavy view camera, or maybe even several cameras if she wanted to make stereographs or negatives of different sizes (each variation required a different camera). She also needed tripods, glass plates, and chemicals. A postcard endorsing a female photographer working at the Mt. Tom Summit House shows her bulky camera (fig. VII-1). After 1888 a woman could opt for the convenience of the Kodak, which could be easily held in one hand. A fresh group of photographers took advantage of the ease of operating the camera and subsequent development. "You Press the Button, We Do the Rest," the Eastman Company promised. The simplicity of taking pictures with Eastman's Kodak made it the ideal instrument of tourism. The company aimed their early advertising campaign at a female audience who were now more frequently hopping bicycles, carriages, and ocean liners to undertake excursions. Whether they were touring their hometowns or visiting more-exotic locales in Europe, Asia, or the American West, they usually had a Kodak in tow.[140]

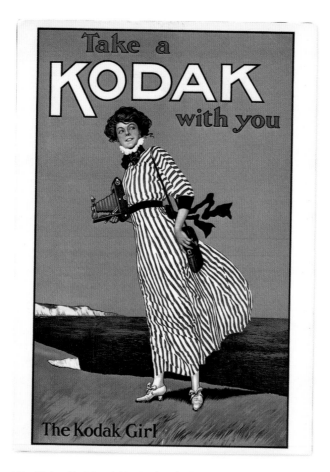

VII-2 "Take a Kodak with You," colored advertisement, 1890s, private collection

"Take a Kodak with you," one advertisement (fig. VII-2) read, showing a smartly dressed modern woman at the seashore with a camera case dangling at her side while she held her amazingly portable new camera—bellows extended—in her right hand. Increasingly, the Eastman Company appealed to women, running promotions such as this one in the so-called ladies magazines. Strategically linking its camera with the freedom of travel and the open road, they directly targeted female consumers with come-ons such as "give the society girl a summer in Colorado" and "all out-doors invites your Kodak." As more middle- and upper-middle-class women accustomed themselves to the ease of this new process, they put photography to a variety of purposes, from creating their own pictorial travel diaries to personal artistic expression.[141]

This change in women's photographic habits is immediately apparent when we compare the ad for the Kodak girl to the female photographer working at the Mt. Tom Summit House. While both link tourism and photography, the one is an amateur enjoying her own trip, while the other is a professional attempting to sell

scenic souvenirs to tourists staying at this well-known resort overlooking the Connecticut River in Mt. Holyoke, Massachusetts. The Mt. Tom woman is dressed in buttoned-up Victoria garb with her hair piled formally on her head, while the Kodak girl attires herself in a sporty striped dress, her hair blowing in the wind. Most importantly, the Mt. Tom woman operates a large bellows camera mounted on a sturdy tripod, while the Kodak girl effortlessly carries her Kodak with one hand. Although not separated so far apart in time, the Mt. Tom woman represents the past while the Kodak girl looks to the future.[142]

VII-3 "Buckeye Camera," black-and-white advertisement, 1890s, private collection

These developments marked the birth of the photographic amateur, referencing the traditional meaning of the term "amateur" as one who loves and practices an art for pleasure rather than profit. Camera companies began to pitch their products increasingly to these amateurs, who were often gendered female (fig. VII-3). The Chicago branch of E. & H. T. Anthony & Co. featured a youthful, attractive female aiming her camera at a mirror, taking her self-portrait. A notice that appeared just below the woman read: "If you are an amateur photographer, and will send us your name and refer to this publication, we will send you from time to time announcements of new apparatus and photo specialties." The address to which one applied was "Amateur Sales Department," an acknowledgment that these not-for-profit practitioners were a new force in image making.

"How a Woman Makes Landscape Photographs"
by Eliza W. Withington

Philadelphia Photographer 13 (1876): 357-60

FRIEND *Mosaics:* I have read friend Wilson's invitation "that we write thee a short letter." What can I write about? Others so much better informed scientifically, and more experienced practically, have and will write in those departments of photography in which it would be absurd for me to say aught. When the savants and producers in photography talk, I can but listen. Yet, I would pay thee my respects. Suppose I tell thee how a woman makes landscape photographs?

Here in the valley, for four months, the temperature is very high, too high for comfort or good photographic work, for several of the midday hours of those months the thermometer coquets with the Centennial number, often getting the better of it from ten to twenty degrees in the shade. When those days come I begin to finish up and dismiss local work, clean 5 × 8 plates, select and arrange my chemicals in compact little packages or small bottles (as the exigency of the case requires), and put by in some convenient place ready for packing when the time draws nigh, in which I may hie [*sic*] me to the mountains.

We have some of the prettiest little lakes, the loveliest valleys, the most picturesque and stupendous mountains, peaks, etc., of the Sierra Nevada range in our county, and what was a few years again, but was divided off, and now is named Alpine County.

In these counties is the old Emigrant or Carson road, and the people have gratefully immortalized the old pioneer, Kit Carson, by giving his cognomen to some of the grandest wildest, and most peculiar peaks, spurs, etc. Here we have Carson River, Carson Creek, Carson Canon, Carson Spur, Carson Peak, Carson Valley, Carson City, and Carson Road, and the richest gold and silver mines in the world, excepting, perhaps, one or two, until ours are more fully developed. Now I think of it, I never have heard of a Carson Mine; that must be looked to, and have that so no more.

Well, friend *Mosaics* Wilson will say, "This is not photography!" Perhaps not; but it is in the suburbs, and, in future years, must be densely photographic.

I have box just long enough to let my Newell bath-tub fit in one side by having notches cut in the ends to let the ears of the Newell bath-tub rest on, the tub then reaches within half an inch of the bottom of the box, in the bottom of which is a thick layer of cotton-batting to absorb any leakages and break the jolts on contexts of box, and some awful ones they get; but I never have had a bottle broken while traveling, but it is death to porcelain dishes. After two trials, I used only iron and wooden developing and fixing trays. My box is about three times as wide as the bath-tub; in the two-thirds space I pack a two-quart bottle of negative bath, a

collodion pouring bottle, one of negative varnish, a small vial each of ammonia, nitric and acetic acid, alcoholic pyrogallic intensifier, bichloride of mercury and alcohol, a small package each of iron and hyposulfite of soda, a small fluid or Lucene oil-lamp, and a box of parlor matches. After all are packed, I turn over the top two rubber funnels, one for filtering the silver-bath, the other for filtering more developer, and all is incased in a strong cloth sack with a carpet bottom and a shirrstring in the top; when drawn close around the inverted funnels and tied, all is snug and secure. The box has wooden slits on the sides to lift by, by taking hold of sack and all.

My negative box holds thirty-two 5 × 8 plates, which are albumenized. I prepare about fifty more, and pack by laying out a thick, large sheet of white wrapping paper. First lay on it a plate incased in a thin blotting-paper twice its size, so there is no danger of its getting misplaced by slipping out, or otherwise, having written on the underside "albumen side," and continue to lay plates albumen side down, and tissue or blotting-paper between. When the number wished is completed they are rolled snugly in the wrapping-paper, and a towel around the hole, then the package fits nicely into my little wooden tray, 6 × 9 inside, for hypo-bath, which again is placed in a common sheet-iron backing-pan of small size, which is used, if necessary, to develop over, and when thoroughly washed out, the negative, after fixing, can be placed in it in an inch or so of water, to let the animated subjects "see how" I and Jane, and Jack, Susan, Katie, and Bob do look. "Ah, how black I am!" "Why, I thought that we would be ever so much larger than that!" not one out of twenty ever looking at the beautiful scenery.

Where were we? The plates in the tray, the tray in the iron pan, and now the whole are placed on top of the negative box, which, too, has a strong cloth casing, same as the chemical box. The plateholder, with a piece of red blotting paper in it for back of sensitized plates, is wrapped in the focussing [*sic*] cloth and my handtowel around that, and placed at the side of the negative box. If the box is full of plates, and not room for the camel's-hair duster and dipper, they are rolled in tissue paper (of which there is always a supply among the plates in the box), and tucked under the cord that fastens the plate wrappings. When all are in place draw the shirr-string, and tie snug.

The sacks are never removed from the boxes during a trip, being wide enough, when the shirr is straightened out, the top of the sack can be turned down when unpacking and working, and all ready when the boxes are repacked to draw up and tie, and there is plenty of room at the side to tuck in useful things, as this, for instance: there are times when it is too cumbersome to get out the tent and pitch it, etc. and I improvised one by taking a dark, thick dress skirt, that was well fringed by bushes and rocks, sewing two thicknesses of black calico of its width to the bottom, then, when I knew of a view that we were to pass, I would sensitize a plate and by wrapping a wet towel around the plate, and over that the focusing cloth, I have carried it three hours. When the exposure has been made, I throw the skirt over the camera, and pin the band close to the camera box. If the sun is bright, and too much light enters, I throw over all a heavy travelling shawl, and with water, lamp, and developer, I slip under cover, develop the view, wash and replace in plateholder until a more convenient time for fixing and varnishing. Even the stage will sometimes stop so long. The water vessel is a common six-quart watering pot, the sprinkler removed, and the spout supplied with a cork.

I have a good tent (own invention), more properly dark closet, for landscape work when necessary, but I do not often need it; a bed room or clothes closet can so easily be converted into a dark closet, and are safer from accidents from wind or dust. I do wish to, but will defer for the present inflicting on you a description of it, as my letter is getting too lengthy. My patrons always know when I am coming, and often take me in their own conveyance to their residences, or where viewers are to be photographed. At such times I never carry a dark closet, as they always think no place too good, and against all protestations and fears on my part of accidents from spilled water or chemicals, I have several times been forced to use a parlor, Brussels carpet and all, for chemical room.

The camera, the pet, consists of a pair of Morrison lenses, a Philadelphia box and tripod; on short distances I usually carry these, having the legs doubled up and tied, but, if riding far, and I do not want to use it, I take out the screw, invert the lenses, i.e., turn them into the box, turn up the bed-frame, and wrap in the shirt-tent and pack away.

Last but not least in usefulness is a strong black-linen cane-handled parasol. If not absolutely necessary for a cane, and more necessary for a shade, I so use it; and then it is at hand if a view must be taken when the sun is too far in front, to shade the lenses with, or to break the wind from the camera, and for climbing mountains or sliding into ravines a true and safe alpenstock.

With this kit I travelled some hundreds of miles last summer, seeking health and negatives or our mountain scenery, mines, quartz mills, etc. For four months before starting I had scarcely spoken above a whisper; after eight weeks I returned home, speaking as well as ever. See what we can do if we try! Would that more valetudinarians could thus find health and recreation . . .

The spirit hath moved me to write this, I know not why. It is my earnest wish that it may help some beginner situated as I commenced landscaping, without one of the craft to speak with, and had to look alone to books for suggestions, in which *Mosaics* and the *Philadelphia Photographer* were my best counsellers.

"What a Woman Can Do with a Camera"
by Frances Benjamin Johnston

Ladies Home Journal 14, no. 10 (Sept. 1897): 6–7

In order to solve successfully the problem of making a business profitable, the woman who either must or will earn her own living needs to discover a field of work for which there is a good demand, in which there is not too great competition, and which her individual tastes render in some way congenial.

There are many young women who have had a thorough art-training, whose talents do not lift their work above mediocrity, and so it is made profitless; others who, as amateurs, have dabbled a little in photography, and who would like to turn an agreeable pastime into more serious effort; while still another class might find this line of work pleasant and lucrative, where employment in the more restricted fields of typewriting, stenography, clerking, bookkeeping, etc., would prove wearing and uncongenial to them.

Photography for Women

Photography as a profession should appeal particularly to women, and in it there are great opportunities for a good-paying business-but only under very well defined conditions. The prime requisites--as summed up in my mind after long experience and thought--are these: The woman who makes photography profitable must have, as to personal qualities, good common sense, unlimited patience to carry her through endless failures, equally unlimited tact, good taste, a quick eye, a talent for detail, and a genius for hard work. In addition, she needs training, experience, some capital, and a field to exploit. This may seem, at first glance, and appalling list, but it is incomplete rather than exaggerated; although to an energetic, ambitious woman with even ordinary opportunities, success is always possible, and hard, intelligent and conscientious work seldom fails to develop small beginnings into large results.

The Best Field for a Beginner

The range of paying work in photography is wide, and most of it quite within the reach of a bright, resourceful woman. Regular professional portraiture is lucrative if it is made artistic and distinctive, but it involves training, considerable capital, an establishment with several employees, and a good deal of clever advertising. Under these circumstances the most successful way would be to gravitate into studio portraiture after a few years of careful apprenticeship and experience in other lines.

As a rule the beginner will find her best opportunity, and her chances of success greatly multiplied if she is able or originate and exploit some field of work. In this direction there are many openings, such as interior and architectural work, the copying of paintings, "at home" portraits, outdoor picture of babies, children, dogs and horses, and of country houses, photography for newspapers, and magazines and commercial work.

Developing and printing for amateurs, and the making of enlargements, transparencies, and lantern-slides have also been made profitable by a goodly number of women in some of the larger cities.

The ancient law of demand and supply governs the market price of photographs, just as it does any other commodity, and, therefore, the woman who contemplates making photography a business should first take a careful survey of "her" individual circumstances and surroundings, with a view to finding out just what are the photographic needs of her immediate neighborhood. Of course, there are always large possibilities is showing people what it would be advantageous to have in the way of pictures; but the best general rule to follow is to accept cheerfully any work that comes, doing what there is to do rather than waiting for the particular kind that one would prefer. Usually a business woman who shows a disposition to do anything asked of her in her line of work, soon finds herself able to exercise some choice in the matter pursuing her own taste and pleasure.

Training Necessary for Good Work

The training necessary to produce good work is, after all, probably the most difficult part of the problem of making photography pay. While there are few schools of photography in the large cities, most of them are designed to help the amateur out of her difficulties rather than to give a thorough and practical training for the business. Experience, therefore, is about the only reliable teacher, and the quickest way to obtain it is to serve an apprenticeship in the establishment of some professional photographer, who has a good knowledge of his profession. Unfortunately for the tyro, most of these neither have neither time nor inclination to teach photographic processes, but there is frequently a chance of obtaining employment in photographic studios in consideration of the experience to be acquired. Even if a woman finds such an opportunity it is most important that she learn to think for herself, and to keep her own ideas and individuality in her work.

The bane of the average professional photographer is the deadly commonplace-and it is safe to say that the majority of those who fail to make their business pay, do so because they are not progressive in keeping up the advancement of the art, and lack originality.

The best camera clubs all over the country have opened their doors to women, and when these societies are at all progressive the beginner may obtain many very useful and helpful hints by an exchange of experiences and ideas at the meeting of their organizations.

When Distinction and Originality are Aimed at

To those ambitious to do studio portraiture I should say, study art first and photography afterward, if you aim at distinction and originality. Not that a comprehensive technical training is unnecessary, for, on the contrary a photographer needs to understand his tools as thoroughly as a painter does the handling of his colors and brushes. Technical excellence, however, should not be the criterion where picturesque effect in concerned. In truth, to my mind, the first precept of artistic photography is, "Learn early the immense difference between the photography that is merely a photograph, and that which is also picture."

Any person of average intelligence can produce photographs by the thousand, but to give art value to the fixed image of the camera-obscura requires imagination, discriminating taste, and, in fact, all that is implied by a true appreciation of the beautiful. For this reason it is wrong to regard photography as purely mechanical. Mechanical it is, up to a certain point, but beyond that there is a great scope for individual and artistic expression. In portraiture, especially, there are so many possibilities for picturesque effects-involving composition, light and shade, the study of pose, and arrangement of drapery-that one should go for inspiration to such masters as Rembrandt, Van Dyck, Sire Joshua Reynolds, Romney and Gainsborough, rather than to the compliers of chemical formulae. In fine, learn everywhere and of everybody study carefully the work of other photographers, whether good, bad or indifferent; be sure to always regard your own productions with a severely critical eye-never an over-indulgent one; guard against this, and, above all, never permit yourself to grow into a state of such superior knowledge that you cannot glean something for the humblest beginner.

It would be impossible in so short a paper to give any detailed suggestions as to the best methods of developing, printing, etc. Most dealers and photographic supplies present neat little books of instruction with the cameras they sell, well every box of standard-brand plates contains printed slip of well-tried formulae.

In general one may advise the beginner to be exact, infinitely careful in the matter of details in carrying out instructions intelligently and to the letter. It is also well, in all photographic processes, not to take any liberties with chemicals by missing them up regardless of formulae. In the matter of jars, bottles and trays, learn early that "chemically clean" means something more than merely "clean". Plenty of water will generally be found, of not a panacea, a preventative of many of the spots and stains and both negative and prints which so often agonize the soul of the tyro.

As to apparatus, it is also impossible to offer any but general suggestions for the obvious reason that no one lens nor camera will cover the entire field of photographic work. Each worker must study what is best suited to her particular line, and be guided accordingly. The only universal rule is to buy the best apparatus obtainable-the prime consideration being fine lenses.

The ideal outfit for all round outdoor and indoor work would be a six-and-a-half by eight-and-a-half- inch or eight by ten-inch camera, light in weight, compact and simple simply in construction-that is, easy to carry, easy to use and easy to keep in order-a light, but rigid, tripod, and a few extra plate-holders. For a plate eight by ten inches have two lenses of the rapid, symmetrical form, the first about fifteen inches in focal length for architectural and general outdoor work, also for portraits, groups, copying, etc. A second lens of about ten-inch focus is of great use in confined situations. Both lenses should be equipped with combination time and instantaneous shutters. A wide-angle lens of about six-inch focus for interiors is also necessary. All these, of the best and new would cost about three hundred dollars. But there are bargains to be found in second-hand photographic apparatus, especially in lenses.

Even if a beginner should be possessed of the necessary capital it would be wiser to start with a modest outfit. This could consist of an inexpensive camera and one fine lens; then if the enthusiasm for the workout outlasts all difficulties something more adequate could be obtained.

The Dark Room

In improvising an "at home" darkroom the bathroom is usually the first resource; equally as a rule, the appropriation of it for this use involves the inconvenience of the rest of the household. It is better, when possible, to make arrangements for water connection in another room, which can also be kept cool and well ventilated. Verily the woes of the photographer are multiplied a thousandfold by small, hot stuffy dark-rooms. If a good-sized room with several windows in it, is available, is quite easy to make it "light-tight" by pasting several thickness of yellow post-office or ruby paper of the panes, stopping up the chinks with flaps or dark felt, and it necessary using yellow cloth curtains. A room so darkened should be tested for light-leaks before it is regarded as a safe place in which to handle plates.

If possible place the developing sink in front of a window which has been in part darkened with post-office paper, and the rest-at least one good sized pane-glazed with two thicknesses of ruby and one sheet of ground glass. On the outside of the window, in a sheltered box, place either a gas jet or an oil lamp, insuring a cool dark-room, and a steady even light which is of the greatest importance-in fact it is absolutely essential.

As to dark-room accessories it is better to have a few simple, useful things than to waste money on all sorts of expensive patented devices, which, as a rule, prove encumbrances. The greatest dark-room luxury-after running water and proper ventilation-is an abundance of large, deep, hard-rubber trays. It is simply a waste of money to buy any other kind. If possible, have separate trays for developing and toning, and never use the "hypo" tray for any other purpose.

Arrangement and Management of a Portrait Studio

Photographic portraiture should prove as charming and congenial as a field for artistic effort as a woman could desire; and that it is lucrative is well demonstrated by many women who are successfully established in the business. To properly conduct a photographic studio experience, training and capital are required. Nothing more, however, than is necessary to enter other professions, with the added advantage that, for the start, photography is usually made to pay something.

The ideal studio is, of course, the one built or remodeled to suit the exact needs of the photographer. But, in most instances, the woman entering professional photography will be obliged to content herself with what she can find ready to her use.

My studio room is eighteen by thirty-two feet, single slant skylight with ribbed glass, on an angle of about sixty-five degrees, and twelve by sixteen feet in size. Ribbed glass gives soft, diffused light so desirable for effective portraiture but needs to be further screened with transparent white curtains of the entire skylight, and,

on occasion, patches of semi-translucent curtains to town down the intense high-lights. Inside the white curtains are opaque shades on rollers, which overlap and serve to shut out the light whenever necessary.

I have tried to make my skylight room as artistic, as cheerful and as inviting as would be the studio of an artist. Most people consider dentistry and having their picture taken as being equally unpleasant and painful, and shrink from one quite as much as they do from the other. I do not know if dentistry can be robbed of its terrors, but I am sure that the imaginary sufferings of those who visit the photographer can be to a great extent mitigated-in fact, can be wholly dispelled by making the studio of the photographic artist inviting and attractive. This is a very good factor in making portraiture photography a success. I fully understand and appreciate the fact that every photographic studio cannot be metamorphosed into an artist's den. This of course, is impossible, and in many instances it would not prove profitable undertaking. Again it might not be suitable to transform a photographic establishment, and beside it might prove the very opposite of convenient. However, the point that I wish to give emphasis to is that a woman of good taste with exercise it in order to avoid the bare ugliness and painful vulgarity of the ordinary "gallery," and make it her careful studio to render her surroundings as attractive and beautiful as possible. I must not be misunderstood as saying that the galleries of all photographic artists are ugly and vulgar in appearance, for I only want to say that with a little additional effort the usual photographic establishment can be made much more attractive and inviting to the public, also much more in harmony with art. I think that what I have said makes entirely plain the value is set upon making the studio inviting.

The Studio's Equipment and Its Cost

On a conservative estimate it would cost between one thousand and two thousand to properly equip a photographic studio, if lenses, cameras, backgrounds and furnishing are to be bought. Even more than two thousand dollars can often be profitably spent, but that sum will secure a complete outfit. Of course it is always possible to make a very modest beginning, but, in any event, some capital is needed until the work becomes known and the business reaches a paying basis.

In general, for the fitting of a studio I should recommend a good-sized- say eleven by fourteen inches-camera, with extension bellows adjusted to take various sized plates from cabinet size-five by seven inches-up; and with at least six of eight light plate-holders of each of the smaller sizes-the best portrait lens obtainable. Also two or three plain, rather than ornamental, backgrounds (a strip of seventy-two-inch gray felt, five yards long, stretched upon a light wooden movable frame, making an excellent ground for general use); and five or six pieces of furniture, such as chairs, benches and stools of good artistic design. By simple and effective belongings rather than the showy papier mâché accessories and fuzzy wicker furniture, the injudicious use of which so frequently ruins an other wise beautiful portrait.

Sitters Before the Camera

The actual work under a skylight, only a few general hints may be given, as here each must "work out her own salvation." Do not attempt to pose people, or to strain our sitters into uncomfortable or awkward position, in order to obtain picturesque effects. Watch them, and help them into poses that are natural and graceful. Study their individuality striving to keep the likeliness, and yet endeavoring to show them at their best. Avoid emphasizing the peculiarities of a face either by lighting or pose; look for curves rather than angles for straight lines, and try to make the interest in the picture center upon what is most effective in your sitter. The one rule of lighting is never to have more than a single source of light. Many portraits, other wise good, are rendered very inartistic by being lighted for several different directions.

Another consideration of the first importance is not to permit portrait negatives to be over-retouched. It is not too much to say that this is the worst fault of the average professionals. Their work strikes the level of inanity because they consider it necessary sandpaper all the character and individuality out of the faces of their sitters. In regard to the finished work I would strongly advise the use of only the best and most permanent printing processes. "Mounts" should be quiet and effective while correct taste, simplicity and a sense of eternal fitness of things should be displayed in the matter of letterheads, announcement cards at all other forms of advertising. The importance of this often-overlooked detail must be obvious to everyone.

The Business Side of Photography

Good work should command good prices, and the wise woman will place a paying value upon her best efforts. It is a mistake and business policy to try and build up trade by doing something badly cheaper than somebody else. As to your personal attitude, be businesslike in all your methods; cultivate tact, and affable manner, and an unfailing courtesy. It costs nothing but a little self-control and determination to be patient and good-natured under most circumstances. A pleasant, obliging and businesslike bearing will often prove the most important part of a clever woman's capital.

By the judicious improper exercise of that quality known as tact, a woman can, without difficulty (in fact, she can readily), manage to please and conciliate the great majority of her customers-even the most exacting ones. She may do this, too, without being very greatly imposed upon- without being imposed upon at all. Tact, I would emphasize, is a great factor in successfully conducting a photographic studio; it is, I suppose, a virtue to be cultivated by everyone who has dealings with the public, and who is brought to contact with people and whatever business or calling she may be engaged.

Above everything else be resourceful, doing your best with what you have until you are able to obtain what you would like. Resource, a good sense, cultivated taste in hard work for a combination that's seldom fails to success in a country like ours, where a woman needs only the courage to enter and profession suitable to our talents and within her powers of accomplishment.

NOTES

1. Biographical Note on Abraham Bogardus, *The Photo Miniature* (1905).

2. See, for example, Peter E. Palmquist and Thomas R. Kailbourn, *Pioneer Photographers of the Far West: A Biographical Dictionary, 1840–1865* (Stanford, CA: Stanford University Press, 2000) and other references to be found in the bibliography.

3. Barbara Balliet, "Reproducing Gender in Nineteenth-Century Illustrations," *Journal of the Rutgers University Libraries* 60 (2003): 68–69.

4. For a virtual tour and more information, see Mathew Brady's National Portrait Gallery website, https://npg.si.edu/exh/brady/gallery/gallery.html; consulted June 2, 2018.

5. Theodore Roosevelt, *Dante and the Bowery* (New York: Outlook, 1913).

6. Their names and addresses were obtained from the logos on the verso of their *cartes de visite*.

7. Notice in *New York Daily Tribune*, July 12, 1854.

8. The husband-wife relationship is referenced in Matthew Daniel Mason, *Guide to the Julia Driver Collection of Women in Photography: Gen Mss 690* (Yale University Library, Beinecke Rare Book and Manuscript Library, General Collection of Modern Books and Manuscripts, New Haven, CT), p. 7, http://drs.library.yale.edu:8083/fedora/get/beinecke:driver/PDF.

9. "Fine Arts," *New York Herald* 7098 (February 4, 1856): 5; reproduced on the website The Daguerreotype: An Archive of Source Texts, Graphics, and Ephemera, www.daguerreotypearchive.org, consulted May 13, 2019.

10. Ibid.

11. Cuique Suum [pseudonym for unidentified writer], "The Photographic Galleries of America: Number One—New York," *Photographic and Fine Art Journal* [New York] 9, no. 1 (January 1856): 19–21.

12. This transition is discussed in Beaumont Newhall's *The Daguerreotype in America* (New York: New York Graphic Society, 1968), 107–10.

13. Thomas S. Jube, born ca. 1817 in New York, New York; in the 1850s his business was located at 83 Bowery and by 1867–1868 the addresses was 220 Bowery (the business could have moved, or the buildings could have been renumbered); by 1882–1883 there is someone by the same name operating in Minneapolis. See New York Public Library's database Photographer's Identities Catalogue (PIC) website, accessed May 10, 2019: http://pic.nypl.org/map.

14. They were available in the following sizes: Imperial or Mammoth Plate—larger than 6½ by 8½ inches; Whole Plate—6½ by 8½ inches; Half Plate—4¼ by 5½ inches; Quarter Plate—3¼ by 4¼ inches; Sixth Plate—2¾ by 3¼ inches; Ninth Plate—2 by 2½ inches; Sixteenth Plate—1½ by 1¾ inches.

15. US census for 1860. New York, NY (Ward 8, District 3), "dwelling 2, family 2." No reference to her was found in the 1870 census under "Matilda Moore."

16. "Brady's New Photographic Gallery, Broadway and Tenth Street," *Frank Leslie's Illustrated Newspaper* 11, no. 267 (January 5, 1861): 106. The accompanying article on Brady described the elegant gas fixtures, couches, and carpeting. For further information, see Shirley Teresa Wajda, "The Commercial Photographic Parlor, 1839–1889," *Perspectives in Vernacular Architecture* 6 (1997): 216–30.

17. From Trow's City Directory: 1859—no mention of Matilda Moore; 1861 (p. 610)—Moore, Matilda ambrotypes 421 Canal; 1862 (p. 606)—Moore, Matilda ambrotypes 421 Canal; 1865 (p. 627)—Moore, Matilda, wid. Michael, photographs, 421 Canal.

18. [Classifieds] *Photographic Times and American Photographer* 13 (April 1883): 190.

19. "Bogardus Studio," *Philadelphia Photographer* 21 (1884): 255, 291.
 Given the scale of his operation, his was a longer and more expensive ad that provides additional clues about the process of turning over a studio.

20. J. S. Ware, *A Directory for the City of Quincy* (Quincy, IL: J. S. Ware, 1848), 102. At the time, Quincy vied with St. Louis for prosperous growth among cities along the Mississippi.
 One of her early studios stood near the corner of Fourth and Hampshire, roughly four blocks from her residence, located at 709 Broadway Street. Daguerreotypes identified as by "W. A. Reed" are in circulation, produced by her husband before she learned the business.

21. Dissertation by Margaret Denny supplies additional clues into how she ran her business. "Excelsior Pictures!," *Quincy Wig & Republican* (January 4, 1862).
 Nelson, 77–79. Quoted in Denny, "From Commerce to Art: American Women Photographers, 1850–1900" (PhD diss., University of Illinois at Chicago, 2010), 53.

22. "Daguerreotypes," *Palmyra* (January 31, 1862).

23. Lyndee Job Henderson, *More Than Petticoats: Remarkable Illinois Women* (Guilford, CT: Two Dots, 2007), 44–55. Her photographs are located in the Historical Society of Quincy and Adams County, Quincy Public Library; Brenner Library, Quincy University; Peter Palmquist Collection; and other private collections. According to information from the Illinois Women's Art Project, a fire in her studio in 1878 destroyed some of her work.

24. In the United States in 1854, Hamilton L. Smith of Cincinnati was said to have invented of the tintype, which he patented on February 19, 1856. But there were other claims on its discovery, including by Adolphe Martin, who was thought to have presented it in France in 1852.

25. Generally it seems that there is less information given about the operator on tintypes versus cdvs. The tintypes might have a name but no address.

26. "Massillon History: Abel Fletcher, Photographic Pioneer," on Massillon Museum website, www.massillonmusuem.org/221, consulted April 18, 2018.

27. Cdvs include one of a little child smiling [that's rare] in posing chair, printed on verso: "Photographed by Mrs. M. M. Fletcher, Massillon, Ohio," and another of a women in plaid (Scottish?) skirt and sash with her name written in pen at the bottom of the image [hard to read; Ida Sribec?], printed on recto: "Mrs. A. Fletcher, Massillon, Ohio." It also has a revenue stamp on the verso.

28. These two tintypes display different styles of back marks, indicating they were done at different times. The young woman's is stamped "Made at Mrs. Fletcher's Gallery Massillon, Ohio" in a linear boarder. The young man's reads "Mrs. Fletcher, Photographer, Massillon, Ohio" in an oval surrounded by decorative motifs.

29. Joseph Mitchell, "McSorley's Wonderful Saloon" [1943], in *Up in the Old Hotel, and Other Stories* (New York: Random House, 1992), 214.

30. She is included in Peter E. Palmquist and Gia Musso, *Women Photographers: A Selection of Images from the Women in Photography International Archive, 1852–1997* (Kneeland, CA: Inaqua, 1997).

31. Janice Schimmelman, *The Tintype in America: 1856–1880* (Philadelphia: American Philosophical Society, 2007), 54.

32. Certain photos, including those bound into books, and gem-types (too small to have a stamp affixed) were subject to 5% tax, which would be paid in cash (in lieu of stamps) by the photographer. See David A. Norris, "Revenue Stamps & Civil War Photography," *Military Images* 20, no. 6 (May–June 1999): 13–15.

33. The earlier revenue stamps were designated for a variety of specific purposes, such as "bank check," "contract," and so on, but with over 25 different titles it was difficult to keep them stocked, which led to complaints. Later in 1862 the law was changed to make them more interchangeable. Ibid.

34. 1c, 2c, and 3c were printed usually in red (which faded to the reddish-brown color seen today) and also blue, green, and orange. They were printed by the Philadelphia firm of Butler & Carpenter.

35. Ibid.

36. Born in West Indies, Elizabeth Israel was listed in the 1860 census as photographer in Baltimore.

37. Addresses can be found on the photographs and in the city directory.

38. *Cartes de visite* by Israel in the Library of Congress collection, for example, depict an unidentified Confederate private and Lt. George Washington Purnell of the Virginia Cavalry Regiment. Additional examples can be found in the Maryland Photographers Collection of the Maryland Historical Society.

39. David Levine, "How the Hudson Valley Changed the Civil War," *Hudson Valley Magazine* website, www.hvmag.com/core/pagetools.php?pageid=8317&url=%2FHudson-Valley-Maga-zine%2FApril-2011%2FHow-the-Hudson-Valley-Changed-the-Civil-War%2F&mode=print; consulted April 8, 2019.

40. There are two additional cdvs in the Julia Driver Collection, Beinecke Library, Yale University.

41. Martha Louise Rayne, *What Can a Woman Do; or, Her Position in the Business and Literary World* (Detroit: F. B. Dickerson, 1884), 126–27.

42. Grant B. Romer and Brian Wallis, eds., *Young America: The Daguerreotypes of Southworth & Hawes* (Göttingen, Germany: Steidl, 2005).

43. Rayne, *What Can a Woman Do*, 126–27.

44. Felicity Tsering Chödron Hamer, "Helen F. Stuart and Hannah Frances Green: The Original Spirit Photographer," *History of Photography* 42, no. 2 (2018): 146–67.

45. Today what is left of the hotel is supposed to house the Capital City Museum. The building is over 150 years old; it burned in 1917, leaving only a part of the building left.
　　Information supplied by Russ Haller, historian at the museum. See also the website www.frankfortparksandrec.com/html/capital_city_museum.

46. Civil War Collection, University of Washington Library.

47. Elizabeth Siegel, in *Galleries of Friendship and Fame: A History of Nineteenth-Century American Photograph Albums* (New Haven, CT: Yale University Press, 2010), 61, discusses Mathew Brady in this light.

48. The local militia successfully fought off an attacking detachment of John Hunt Morgan's cavalrymen in June 1864. Lt. Sanford Goin was awarded an ornate sword for his part in the action (now in the local museum).

49. "Photography," *Frankfort Commonwealth*, November 10, 1865; the same notice was repeated on December 29, 1865, p. 1

50. Ibid.

51. "Legislative Directory," *Daily Commonwealth* [Frankfurt, KY], February 10, 1854.

52. For the tradition of gift-giving including silver and tableware, see Barbara Penner, "'Vision of Love and Luxury': The Commercialization of Nineteenth-Century American Weddings," *Winterthur Portfolio* 39, no. 1 (Spring 2004): 1–20.

53. *McPherson Daily Republican*, April 3, 1890; quoted on Photographs, Pistols & Parasols: Celebrating Early Women Artisan Photographers website, http://p3photographer.net/p3p021, on Vreeland; consulted May 23, 2019.

54. Virginia Hartley Stiles was married to Edward Hartley, who had a photographic business in Chicago. After his death, his brother managed the business, and Virginia Hartley—although she remarried—remained active in the business.

55. *Chicago Daily Tribune*, October 5, 1890: 31; quoted in Margaret H. Denny, "From Commerce to Art: American Women Photographers, 1850–1900" (PhD diss., University of Illinois at Chicago, 2010), 115.

56. Marriage Certificate with Tintypes of Augustus L. Johnson and Malinda Murphy, https://nmaahc.si.edu/object/nmaahc_2016.58; consulted June 5, 2019.

57. See the more complete discussion of Pirie MacDonald, pp. 117–119.

58. Information on the cabinet card identifies her as Mrs. W. A. Robinson, who did "Art Photography" at 170 East 126th Street, New York. On the reverse she proudly illustrated the recto and verso of a medal she had won: "The Medal of Merit awarded to Mrs. W. A. Robinson for Photographs, 1890" and "American Institute, New-York." In 1880, according to city directories, she had been located at 631 W. Lake, Chicago.

59. Frances Elizabeth Willard, *Occupations for Women* (Cooper Union, NY: Success Co., 1897), 504.

60. In *Galleries of Friendship and Fame: A History of Nineteenth Century American Photographic Albums* (New Haven, CT: Yale University Press, 2010), Elizabeth Siegel investigates the consumption of *carte de visite* by women, who organized them into albums for display in the home. She examines how they were marked and how families told their stories through them, but never mentions the fact that many women were also the camera operators who produced the images.

61. Martha Louise Rayne, *What Can a Woman Do; or, Her Position in the Business and Literary World* (Detroit: F. B. Dickerson, 1884), 126–27.

62. "Art Notes: A Picture by Cotman," *Boston Evening Transcript*, April 26, 1889.

63. Emily Stokes, "Plain Portraiture," *Wilson's Photographic Magazine* 37 (March 1900): 97.

64. Stacy S. Hollander, in *Securing the Shadow: Posthumous Portraiture in America* (New York: American Folk Art Museum, 2017), provides an excellent overview.

65. Quoted in Kelly Christian, "The Unpleasant Duty: An Introduction to Postmortem Photography," The Order of the Good Death website: www.orderofthegooddeath.com/unpleasant-duty-introduction-postmortem-photography. Consulted May 14, 2019.

66. Mr. and Mrs. Charles Waldack operated galleries in Ohio; for background, see Mary Sayre Haverstock, comp. and ed., *Artists in Ohio, 1797–1900: A Biographical Dictionary* (Kent, OH: Kent State University Press, 2000), 900.

67. Brady quoted in Hollander, *Securing the Shadow*, 42.

68. Oliver Wendell Holmes, "Sun-Painting and Sun-Sculpture," *Atlantic Monthly* 8 (July 1861): 14, quoted in Hollander, *Securing the Shadow*, 35.

69. Anne Higonnet, *Berthe Morisot* (New York: Harper Perennial, 1991), 10.

70. Toni A. H. McNaron, ed., *The Sister Bond: A Feminist View of a Timeless Connection* (New York: Pergamon, 1985), 5.

71. Mary R. Reichardt, "'Friends of My Heart': Women as Friends and Rivals in the Short Stories of Mary Wilkins Freeman," *American Literary Realism 1870–1910* 22, no. 2 (Winter 1990): 54–68.

72. Carroll Smith-Rosenberg, *Disorderly Conduct: Visions of Gender in Victorian America* (New York: Knopf, 1985), 62.

73. *Philadelphia Photographer* 11 (1874): 115.

74. Freeman Tilden, in *Following the Frontier with F. Jay Haynes, Pioneer Photographer of the Old West* (New York: Knopf, 1964), states that he completed his apprenticeship with the owner of a studio in Saline, Michigan, in 1875. Since she was the only photographer there at the time, she must have been Haynes's teacher.

75. This biography derives from an entry on Gillett from Saline Area Historical Photos, University of Michigan Library, and from David V. Tinder, comp., *Directory of Early Michigan Photographers*, ed. Clayton A. Lewis (Ann Arbor: William L. Clements Library, University of Michigan, 2013), n.p. (954th unnumbered page).

76. Shirley Teresa Wajda, "The Commercial Photographic Parlor, 1839–1889," *Perspectives in Vernacular Architecture* 6 (1997): 216–30.

77. Thomas Le Clear's painting *Interior with Portraits* (ca. 1865; Smithsonian American Art Museum) draws upon that same assumption, although in this case he depicts a painter's studio that doubles as a photographic parlor.

78. The Musée Nicephore-Niepce among the few surviving structures, but he was a pioneer photographer in France and worked very early in the century.

Casa Relvas—in central Portugal—was built by the eccentric Carlos Relvas, a cutting-edge home for photography consisting of a glass-and-iron studio on the second floor (where he would use curtains to control the light) and a first-floor work space with closed windows for darkrooms and processing negatives.

79. This assessment quoted from what appears to be a report on local businesses in Springfield, Missouri, in 1889. The motto was stamped on each photograph. This one is inscribed by hand in pencil: "Mr. McNulty when he was working on Railroad."

80. Stereograph 2 is identified as "looking back from the front door."

81. Frances Benjamin Johnston, "What a Woman Can Do with a Camera: With Reproductions of Photographs Taken by the Author, and Here Published for the First Time," *Ladies Home Journal* 14 (September 1897): 6.

82. "Chip" [pseudonym], *How to Sit for Your Photograph* (Philadelphia: Benerman and Wilson, 1871) [copy in Library of Congress]. Many such manuals continued to be written. See, for example, "The Effect of Dress in Photography," in *Gay's Illustrated Circle of Knowledge*, by William Gay (New York: Gay Brothers, 14 Barclay Street, 1886).

83. Review of *How to Sit for Your Photograph*, *Photographic Times* 2 (January 1872): 1–2; reprinted in *History of Photography* 11, no. 4 (October–December 1987): 333–34.

84. Johnston, "What a Woman Can Do with a Camera," 6.

85. "The Effect of Dress in Photography," reprinted in *History of Photography* 11, no. 4 (October–December 1987): 333–34. Communicated by Michael Scharfman.

86. Harvey S. Teal, *Partners with the Sun: South Carolina Photographers, 1840–1940* (Columbia: University of South Carolina Press, 2000).

87. George B. Ayres's *How To Paint Photographs in Water Colors and in Oil [Coloring]: How to Work in Crayon, Make the Chromo-photograph, Retouch Negatives and Instructions in Ceramic Painting*, 5th ed. (New York: Daniel Appleton, 1878). Fifth edition considerably enlarged from the 1869 first edition.

88. Willard, *Occupations for Women*.

89. *Philadelphia Photographer* (1873) and elsewhere.

90. Martha Louise Rayne, in *What a Woman Can Do; or, Her Position in the Business and Literary World* (Detroit: F. B. Dickerson, 1884), includes an entire chapter on "Coloring Artists," 120–29.

91. *San Francisco Daily Herald*, November 1850, quoted in Mary Brown, "A Woman's View: 19th Century San Francisco Women Photographers," from the CD-ROM *Shaping San Francisco*, www.shapingsf.org. No further details provided for the newspaper citation.

92. On Dutcher, see www.shapingsf.org/ezine/womens/postgrph/main.html, which provides good background on women in California in the 1860s and 1870s.

93. Quoted in Peter E. Palmquist, "Pioneer Women Photographers in Nineteenth-Century California," *California History* 71, no. 1 (Spring 1992): 148–149.

94. *McPherson Republican and Weekly Press*, April 30, 1886.

95. *McPherson Daily Republican*, April 22, 1890. Quoted on Photographs, Pistols & Parasols: Celebrating Early Women Artisan Photographers website, http://p3photographers.net/p3p021, on Vreeland; consulted May 23, 2019.

96. *McPherson Daily Republican*, February 27, 1890. Quoted on Photographs, Pistols & Parasols: Celebrating Early Women Artisan Photographers website, http://p3photographers.net/p3p021, on Vreeland; consulted May 23, 2019.

97. *McPherson Republican*, August 7, 1896. Quoted on Photographs, Pistols & Parasols: Celebrating Early Women Artisan Photographers website, http://p3photographers.net/p3p021, on Vreeland; consulted May 23, 2019.

98. *McPherson Republican*, August 7, 1896.

99. *McPherson Freeman*, September 24, 1886. Quoted on Photographs, Pistols & Parasols: Celebrating Early Women Artisan Photographers website, http://p3photographers.net/p3p021, on Vreeland; consulted May 23, 2019.

100. *McPherson Daily Republican*, April 3, 1890.

101. "L. M. Prince & Bro. 148 West Fourth Street, Cincinnati, Ohio. Ohio agents for the Blair camera." This advertisement ran widely in the press in the 1880s.

102. On July 25, 1857 the *Amador Ledger* advertised Mrs. E. W. (Eliza) Withington's ambrotype gallery; Peter E. Palmquist, in "Pioneer Women Photographers in Nineteenth-Century California," *California History* 71, no. 1 (1992): 122–23, summarizes details of her biography.

103. "Editor's Table: Pictures Received," *Philadelphia Photographer* 14, no. 157 (January 1877): 31.

104. Eliza W. Withington, "How a Woman Makes Landscape Photographs," *Philadelphia Photographer* 13 (1876): 357–60, reprinted here.

105. David Haynes, *Catching Shadows: A Directory of Nineteenth-Century Texas Photographers* (Austin: Texas State Historical Association, 1993).

106. A substantial collection of her work can be found in the digital collection of Texas: Photographs, Manuscripts and Imprints, DeGolyer Library, Southern Methodist University. Two recent exhibitions on San Antonio photography include *Destino San Antonio*, Briscoe Western Art Museum, San Antonio, 2018–2019; and *La Puerta: A Photographic Journey of San Antonio*, Institute of Texan Cultures, San Antonio, 2018–2019. Neither show produced a catalog; information from a review of the exhibitions is in Gene Fowler, "'A Traveler's Curiosity' and Historic Images of San Antonio," *Glasstire*, December 31, 2018, https://glasstire.com/2018/12/31/a-travelers-curiosity-and-historic-images-of-san-antonio/; consulted March 5, 2019.

107. Quoted in Fowler, "'A Traveler's Curiosity.'"

108. This text accompanied her photograph *Portal of Mission San José*, in the DeGolyer Library, Southern Methodist University.

109. University of Arizona Libraries, Mrs. A. S. Addis Photographic Collection, MS 486, contains thirteen cabinet cards with her logo.

110. Katherine Manthorne, ed., *California Mexicana: Missions to Murals, 1820 to 1930* (Berkeley: University of California Press, 2017), 144–46, 160–62.

111. Beverley S. Adam, in *She Rode the Rails* (Lincoln, NE: Universe, 2005), supplies general background, but since it was written as historical fiction, it is not completely reliable. Wyatt's death date has yet to be located, but her last recorded activity was about 1917, so it is thought that she died between 1917 and 1920.

112. Information from website of the city of Holdrege: https://cityofholdrege.org/history/; consulted June 11, 2019.

113. Lori D. Ginzberg, *Untidy Origins: A Story of Woman's Rights in Antebellum New York* (Chapel Hill: University of North Carolina Press, 2005), 13–14.

114. Ultimately, what did the conference accomplish? It produced the Seneca Falls Declaration of Sentiments, which publicized the women's rights efforts. For the women involved, it gave them a sense of identity, a confirmation that they were not alone in their feelings of frustration and desire for better social standing. It also conferred a new sense of confidence that collectively they were stronger than they thought. But much of the impact was arguably as much psychological as practical.

115. Darcy Grimaldo Grigsby, *Enduring Truth: Sojourner's Shadows and Substance* (Chicago: University of Chicago, 2015), provides background.

116. Lorraine Boissoneault, "Amelia Bloomer Didn't Mean to Start a Fashion Revolution," Smithsonian.com; see www.smithsonianmag.com/history/amelia-bloomer, consulted May 24, 2018.
Boissoneault explains that an editorial by a male author that appeared in the *Seneca County Courier* originally suggested the fashion switch, and Bloomer published a response in her paper *The Lily*.

117. Dore Ashton and Denise Brown Hare, in *Rosa Bonheur: A Life and a Legend* (New York: Viking, 1981), discuss the artist's practice of wearing pants.

118. "Woman's Rights Convention," *New York Times*, August 2, 1852: 2; quoted in Gayle V. Fischer, "'Pantalets' and 'Turkish Trowsers': Designing Freedom in the Mid-Nineteenth-Century United States," *Feminist Studies* 23, no. 1 (Spring 1997): 135.

119. Amy Kesselman, "The 'Freedom Suit': Feminism and Dress Reform in the United States, 1848–1875," *Gender & Society* 5, no. 4 (December 1991): 495–510.

120. Internal Revenue Assessment Lists for Michigan, 1862–66, National Archives, Washington, DC; David V. Tinder, comp., *Directory of Early Michigan Photographers*, ed. Clayton A. Lewis (Ann Arbor: William L. Clements Library, University of Michigan, 2013; online edition), 2156; *Michigan Gazetteer and Business Directory for 1867–8* (Detroit: Chapin & Brother, 1867), 249.

121. Her photographs are signed "C. Smith." Ronald Polito, ed., *Directory of Massachusetts Photographers, 1839–1900* (Camden, ME: Picton, 1993), 557, lists her as "Smith, Costillia D.," which is the correct name.

122. "Miss C. Smith," Photographs, Pistols & Parasols, elaborates on the census records that led to this conclusion. http://p3photographers.net/p3p015, consulted May 19, 2018.

123. "Miss C. Smith," Photographs, Pistols & Parasols, http://p3photographers.net/p3p015, consulted May 19, 2018.

124. "How French-Canadian Textile Workers Came to New England," www.newenglandhistoricalsociety.com/how-french-canadian-textile-workers-came-to-new-england, consulted April 7, 2019.

125. *Chicago Photographers, 1847 through 1900: As listed in Chicago Directories* (Chicago: Chicago Historical Society, 1958).

126. In 1895–98 they had a studio at 585 Evanston Avenue (now Broadway near Belmont Avenue). Berglund predeceased Lindquist, who continued the business until about 1917. So she was in business thirty years, fifteen of which she was in business with Berglund.
 Theirs was a cross-generational partnership; when they formed it in 1895, Lindquist was roughly thirty-three years old, and Berglund fifty-five. Both remained single.
 Denny, "From Commerce to Art: American Women Photographers, 1850–1900," 110–12.

127. "Women Who Do Men's Work," *Chicago Daily Tribune*, November 11, 1894: 44.

128. Her studio at 1301 Michigan Avenue (now 18th Street) had previously been occupied by S. L. Stein, who had operated successful photography businesses in Milwaukee and Chicago.

129. "She Aims with Cameras," *Chicago Daily Tribune*, August 24, 1896: 9.

130. The mayor Carter H. Harrison was among those who sat for her.

131. "Applied Photography," *The Photogram* 5 (1898): 310.

132. Marion Foster Washburne, "A New Profession for Women," *Godey's Magazine*, February 1897: 123–28.

133. By 1899 she and her sister Clara formed Tonnesen Sisters Inc.

134. "Applied Photography," *The Photogram* 5 (1898): 310–11.

135. Denny, "From Commerce to Art: American Women Photographers, 1850–1900," 136.

136. Guide to the Pirie MacDonald Portrait Photograph Collection, New-York Historical Society, provides biographical note, finding aids, etc. Website consulted April 3, 2018. http://dlib.nyu.edu/findingaids/html/nyhs/pirie/index.html.

137. Elbert Hubbard, "Why He Cut the Women Out", five-page pamphlet, reprinted from *The Philistine*, January 1901.

138. This information appears on the cover of the Hubbard pamphlet.

139. Frances Benjamin Johnston, "What a Woman Can Do with a Camera: With Reproductions of Photographs Taken by the Author, and Here Published for the First Time," *Ladies Home Journal* 14 (September 1897): 6.

140. Denny, "From Commerce to Art: American Women Photographers, 1850–1900," 331–32.

141. Nancy Martha West, *Kodak and the Lens of Nostalgia* (Charlottesville: University Press of Virginia, 2000), 13.

142. On her camera the woman displays a well-known view of the Mt. Tom Summit House, which was erected about 1900 after the earlier building was destroyed by fire. This building survived until it burned down in 1929. Wyatt Harper, *The Story of Holyoke* (Holyoke, MA: Holyoke Centennial Committee, 1973).

Bibliography

Primary Sources

Ayres, George B. *How to Paint Photographs in Water Colors and in Oil [Coloring]: How to Work in Crayon, Make the Chromo-photograph, Retouch Negatives and Instructions in Ceramic Painting.* 5th ed. New York: Daniel Appleton, 1878. Fifth edition considerably enlarged from the 1869 first edition.

Mason, Matthew Daniel. *Guide to the Julia Driver Collection of Women in Photography: Gen Mss 690.* Yale University Library, Beinecke Rare Book and Manuscript Library, General Collection of Modern Books and Manuscripts, p. 7. http://drs.library.yale.edu:8083/fedora/get/beinecke:driver/PDF.

Peter Palmquist Collection of American Women Photographers. Yale University Library, Beinecke Rare Book and Manuscript Library, with online database: https://archives.yale.edu/repositories/11/resources/1279?stylename=yul.ead2002.xhtml.xsl&pid=beinecke:wipa&clear-stylesheet-cache=yes.

Photographic Art Journal. Beginning in 1851, run/edited by Snelling, son of the man for whom Fort Snelling, Minnesota, was named.

Willard, Frances Elizabeth. *Occupations for Women: A Book of Practical Suggestions for the Material Advancement, the Mental & Physical Development, and the Moral and Spiritual Uplift of Women.* Cooper Union, NY: Success Co., 1897 [includes chapter on "Women and Photography"].

"Women in Photography." Bill Jay on Photography. https://unitednationsofphotography.com/2019/04/24/archive-women-in-photography-1840-1900. Useful analysis of statistical data in America and Britain documenting the number of women working in the field.

Secondary Sources

Baker, Tracy. "Nineteenth-Century Minnesota Women Photographers." *Journal of the West* 28, no. 1 (January 1989): 15–19.

Batchen, Geoffrey. *Forget Me Not: Photography and Remembrance.* Amsterdam: Van Gogh Museum, 2004.

Davidov, Judith Fryer. *Women's Camera Work: Self/Body/Other in American Visual Culture.* Durham, NC: Duke University Press, 2012.

Denny, Margaret. "Catharine Weed Barnes Ward: Advocate for Victorian Women Photographers." *History of Photography* 36, no. 2 (2012): 156–71.

Denny, Margaret H. "From Commerce to Art: American Women Photographers, 1850–1900." PhD diss., University of Illinois at Chicago, 2010.

Gover, C. Jane. *The Positive Image: Women Photographers in Turn of the Century America.* Albany: State University of New York Press, 1988.

Hales, Peter B. *Silver Cities: Photographing American Urbanization, 1839–1939.* Albuquerque: University of New Mexico Press, 2005.

Jenkins, Reese V. *Images and Enterprise: Technology and the American Photographic Industry, 1839 to 1923.* Baltimore: Johns Hopkins University Press, 1975.

Morrow, Delores J. "Female Photographers on the Frontier: Montana's Lady Photographic Artists, 1866–1900." *Montana: The Magazine of Western History* 32, no. 3 (1982): 76–84.

Peavy, Linda S., and Ursula Smith. *Pioneer Women: The Lives of Women on the Frontier.* Norman: University of Oklahoma Press, 1998.

Raymond, Claire. *Women Photographers and Feminist Aesthetics.* Milton, GA: Taylor & Francis, 2017.

Rosenblum, Naomi. *History of Women Photographers.* Paris and New York: Abbeville, 1994.

Severa, Joan L. *Dressed for the Photographer: Ordinary Americans and Fashion, 1840–1900.* Kent, OH: Kent State University Press, 2008.

———. *My Likeness Taken: Daguerreian Portraits in America, 1840–1860.* Kent, OH: Kent State University Press, 2005.

Spence, Jo, and Joan Solomon. *What Can a Woman Do with a Camera? Photography for Women.* London: Scarlet, 1995.

Teal, Harvey S. *Partners with the Sun: South Carolina Photographers, 1840–1940.* Columbia: University of South Carolina Press, 2000.

Wajda, Shirley Teresa. "The Commercial Photographic Parlor, 1839–1889." *Perspectives in Vernacular Architecture* 6 (1997): 216–30.

Wilson, Bonnie G. "Working the Light: Nineteenth-Century Professional Photographers in Minnesota." *Minnesota History* 52, no. 2 (Summer 1990): 42–60.

Daguerreotype

Barger, Susan, and William B. White. *The Daguerreotype: Nineteenth-Century Technology and Modern Science.* Baltimore: Johns Hopkins University Press, 2000.

Davis, Keith F., and Jane L. Aspinwall. *The Origins of American Photography, 1839–1885: From Daguerreotype to Dry-Plate.* Kansas City, MO: Hall Family Foundation in Association with the Nelson-Atkins Museum of Art, 2007.

Font-Réaulx, Dominique de. *The Daguerreotype.* Paris: Musée D'Orsay, 2008.

Gustavson, Todd. *Camera: A History of Photography from Daguerreotype to Digital.* New York: Sterling, 2012.

Newhall, Beaumont. *The Daguerreotype in America.* New York: New York Graphic Society, 1968.

Romer, Grant B., and Brian Wallis, eds. *Young America: The Daguerreotypes of Southworth & Hawes.* Göttingen, Germany: Steidl, 2005.

Wood, John. *America and the Daguerreotype.* Iowa City: University of Iowa Press, 1991.

Calotype

Brettel, Richard. *Paper and Light: The Calotype in France and Great Britain, 1839–1870.* Boston: D. R. Godine, 1984.

Ambrotype

Crawford, William. *The Keepers of Light: A History and Working Guide to Early Photographic Processes.* Dobbs Ferry, NY: Morgan and Morgan, 1979.

Mora, Gilles. *PhotoSpeak: A Guide to the Ideas, Movements, and Techniques of Photography, 1839 to the Present.* New York: Abbeville, 1998.

Nolan, Sean William. *Fixed in Time: A Guide to Dating Daguerreotypes, Ambrotypes, and Tintypes by Their Mats and Cases, for Historians, Genealogists, Collectors, and Antique Dealers.* Portland, OR: Sean William Nolan, 2017.

Orvell, Miles. *Photography in America.* New York: Oxford University Press, 2016.

Taft, Robert. *Photography and the American Scene: A Social History, 1839–1889.* New York: Dover, 1964.

Tintype

Kasher, Steven, and Geoffrey Batchen. *America and the Tintype.* New York: International Center of Photography, 2009.

McKenzie, Barbara. "Tintypes and Archetypes." *Georgia Review* 30, no. 2 (1976): 352–74.

Rinhart, Floyd, Marion Rinhart, and Robert W. Wagner. *The American Tintype.* Columbus: Ohio State University Press, 1999.

Schimmelman, Janice. *The Tintype in America: 1856–1880.* Philadelphia: American Philosophical Society, 2007.

Carte de Visite

Chalabala, Mark. *The American Backmark: The Art and Artistry of the Carte de Visite Imprint, 1860–1890.* Brookfield, WI: Ina Bindery, 2012.

Hamilton, Peter, and Roger Hargreaves. *The Beautiful and the Damned: The Creation of Identity in Nineteenth Century Photography.* Aldershot, UK: Lund Humphries, 2001.

Lukesh, Susan. *Frozen in Time: An Early Carte de Visite Album from New Bedford, Massachusetts.* Raleigh, NC: Lulu Publishing Services, 2016.

Mathews, Oliver. *The Album of Carte de Visite and Cabinet Portrait Photographs, 1854–1914.* London: Reedminster, 1974.

Siegel, Elizabeth. *Galleries of Friendship and Fame: A History of Nineteenth-Century American Photograph Albums.* New Haven, CT: Yale University Press, 2010.

Cabinet Card

Bogdan, Robert, Martin Elks, and James A. Knoll. "Citizen Portraits: Photos as Personal Keepsakes." In *Picturing Disability: Beggar, Freak, Citizen, and Other Photographic Rhetoric.* By Robert Bogdan, Martin Elks, and James A. Knoll, 144–64. Syracuse, NY: Syracuse University Press, 2012.

Mendelsohn Burgess, Rebekah Elizabeth. *The Cabinet Card Studio as Theater: Identity and Transformation in the Victorian Age.* Arcata, CA: Women in Photography International Archive, 1999.

Pettipas, Katherine. "Cool Things in the Collection: Hall & Lowe Cabinet Cards." *Manitoba History* 74 (Winter 2014): 52–53.

Racker, Barbara. "Ruston Photography at the Turn of the Century." *Louisiana History: The Journal of the Louisiana Historical Association* 30, no. 1 (1989): 43–62.

Yablon, Nick. "Encapsulating the Present: Material Decay, Labor Unrest, and the Prehistory of the Time Capsule, 1876–1914." *Winterthur Portfolio* 45, no. 1 (2011): 1–28.

Collodion Process

Boner, Bradly J. "The Wet Collodion Process." In *Yellowstone National Park: Through the Lens of Time.* By Bradly J. Boner, 22–25. Boulder: University Press of Colorado, 2017.

Jacobson, Quinn. *Chemical Pictures: Making Wet Collodion Negatives; Albumen, Salt, and Collodio-chloride Prints.* Denver, CO: Studio Q, 2013.

McCauley, Anne. "Photographs for Industry: The Career of Charles Aubry." *J. Paul Getty Museum Journal* 14 (1986): 157–72.

Osterman, Mark, and France Scully Osterman. *Basic Collodion Technique: Ambrotype and Tintype.* Rochester, NY: Scully & Osterman, 2013.

Wolf, Sylvia. "Modern Medium / Modern Artist Julia Margaret Cameron's Photographs of Women." *MoMA* 2, no. 2 (1999): 8–11.

Kodak Brownie Camera

Goldthwaite, Melissa A. "Body, Camera, Self." In *From Curlers to Chainsaws: Women and Their Machines*. Edited by Dyer Joyce, Jennifer Cognard-Black, and Elizabeth MacLeod Walls, 214–27. East Lansing: Michigan State University Press, 2016.

Olivier, Marc. "George Eastman's Modern Stone-Age Family: Snapshot Photography and the Brownie." *Technology and Culture* 48, no. 1 (2007): 1–19.

Stilgoe, John R. "Brownies." In *Old Fields: Photography, Glamour, and Fantasy Landscape*. By John R. Stilgoe, 83–106. Charlottesville: University of Virginia Press, 2014.

Swanson, Dwight. "Inventing Amateur Film: Marion Norris Gleason, Eastman Kodak and the Rochester Scene, 1921–1932." *Film History* 15, no. 2 (2003): 126–36.

West, Nancy Martha. *Kodak and the Lens of Nostalgia*. Charlottesville: University Press of Virginia, 2000.

Frances Benjamin Johnston

Ausherman, Maria Elizabeth. *The Photographic Legacy of Frances Benjamin Johnston*. Gainesville: University Press of Florida, 2009.

Berch, Bettina. *The Woman behind the Lens: The Life and Work of Frances Benjamin Johnston*. Charlottesville: University Press of Virginia, 2000.

Daniel, Pete, and Raymond Smock. *A Talent for Detail: The Photographs of Miss Frances Benjamin Johnston*. New York: Harmony Books, 1974.

Gushee, Elizabeth M. "Travels through the Old South: Frances Benjamin Johnston and the Vernacular Architecture of Virginia." *Art Documentation: Journal of the Art Libraries Society of North America* 27, no. 1 (2008): 18–23.

Havice, Christine. "In a Class by Herself: 19th Century Images of the Woman Artist as Student." *Woman's Art Journal* 2, no. 1 (1981): 35–40.

Mitchell, Dolores. "The 'New Woman' as Prometheus: Women Artists Depict Women Smoking." *Woman's Art Journal* 12, no. 1 (1991): 3–9.

Przybylski, Jeannene M. "American Visions at the Paris Exposition, 1900: Another Look at Frances Benjamin Johnston's Hampton Photographs." *Art Journal* 57, no. 3 (1998): 61–68.

Rose, Francesca. "Ambassadors of Progress: American Women Photographers in Paris, 1900–1901." *Woman's Art Journal* 24, no. 1 (2003): 55.

Individual, Little-Known Women

Anderson, H. Joyce. "Warren & Candace Reed." MA thesis, Illinois State University, 2003.

Dictionaries & Compendia

Brown, Robert O. *Collector's Guide to 19th Century U.S. Traveling Photographers*. Forest Grove, OR: Brown-Spath, 2002.

Directory of Minnesota Photographers. Minnesota Historical Society. www.mnhs.org/people/photographers/.

Haynes, David. *Catching Shadows: A Directory of Nineteenth-Century Texas Photographers*. Austin: Texas State Historical Association, 1993.

Kreisel, Martha. *American Women Photographers: A Selected and Annotated Bibliography*. Westport, CT: Greenwood, 1990. This book focuses on the 1880s onward and thus doesn't cover the wet-plate collodion era.

Palmquist, Peter E., ed. *Camera Fiends & Kodak Girls: 50 Selections by and about Women in Photography, 1840–1930*. New York: Midmarch Arts Press, 1989.

Palmquist, Peter E. *Shadowcatchers: A Directory of Women in California Photography before 1901*. Arcata, CA: Peter Palmquist, 1990.

Palmquist, Peter E., and Thomas R. Kailbourn. *Pioneer Photographers of the Far West: A Biographical Dictionary, 1840–1865*. Stanford, CA: Stanford University Press, 2000.

Palmquist, Peter E., and Gia Musso. *Women Photographers: A Selection of Images from the Women in Photography International Archive, 1852–1997*. Kneeland, CA: Iaqua, 1997.

Polito, Ronald, ed. *Directory of Massachusetts Photographers, 1839–1900*. Camden, ME: Picton, 1993.

Teal, Harvey S. *Partners with the Sun: South Carolina Photographers, 1840–1940*. Columbia: University of South Carolina Press, 2000.

Tinder, David V., comp. *Directory of Early Michigan Photographers*. Edited by Clayton A. Lewis. Ann Arbor: William L. Clements Library, University of Michigan, 2013.